IMAGES
of America

BALTIMORE'S
HALCYON DAYS

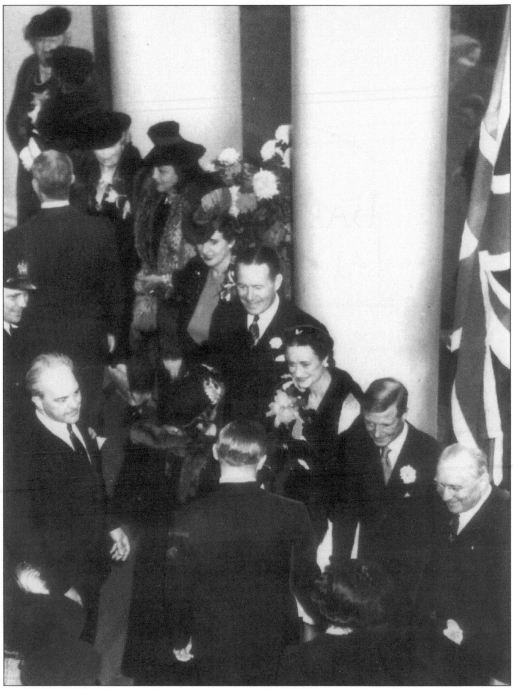

The Duke and Duchess of Windsor receive guests at Baltimore Country Club during their 1941 visit. Also in the receiving line are Governor Herbert O'Conor and Mayor Howard Jackson. The Duchess had been raised in Baltimore and attended the Oldfields School. Her triumphal hometown return was marked by fetes and a parade. (Courtesy Baltimore Country Club.)

IMAGES
of America

BALTIMORE'S
HALCYON DAYS

Brooke Gunning and Molly O'Donovan

ARCADIA

ACKNOWLEDGMENTS

Our deep gratitude goes to our husbands, René and Charlie, and to the following individuals and organizations, among others, for their invaluable time and assistance: Catherine Rogers Arthur, Jessica Atwood, Karen Babcock, Winslow and Peter Barlow, Leigh Brent, Bill Buckingham, Tom Casey, Kate and Courtney Chaplin, Jenkins Cromwell, Mary Ellen Dyer, Jack Elsby, Beth and Mark Felder, Betty Fenwick, Joe Fulco, Tyler Gearhart, Alan Gephardt, Linda Gessner, Mary Gunning, Mary and Rene Gunning Sr., Jim Hardesty, Cindy and John Heller, Paul W. Hogle, Genevia Jackson, Bo and Liza Jarrett, Christine and Tony Kameen, Cindy Kelly, Don Kierson, Jeff Korman, Chris Larsin, Andrea and Jonathan Leavitt, Isaac Lycett, Katharine Mandaro, Leslie Marqua, Patty and Allan Mead, Betsy and Dick Mooney, Tim and Libby Naylor, Betsy Nottingham, Rob Nottingham, Gail and Charlie O'Donovan, Dick Parsons, Paul Spellman, Bill Sawers, Charles C. Stieff II, Kristin Tigart, Suzanne Waller, Lester Watson, Dedi and Hal Whitaker, Vivienne Wilson, Evelyn Zink, Baltimore Country Club, the Baltimore Opera, Baltimore Public Library, The Brass Elephant, Enoch Pratt Free Library, Elkridge Club, Evergreen House, Green Spring Valley Hunt Club, Homewood House Museum, Ladew Topiary Gardens, L'Hirondelle Club, Lightner Photography, Maryland Club, and Preservation Maryland. And a special thanks to all who have prayed for this project's success.

To the best of our ability, we have attempted to ensure accuracy, given the antiquated and often obscure nature of the subject matter and materials.

Finally, but first in our hearts, we would like to acknowledge that this book would not have been possible if we hadn't followed the advice of Colossians 3:17 and Ecclesiastes 4:9-10.

REFERENCES

Barnes, Robert. *The Green Spring Valley: Its History and Heritage, Vol. II.* Baltimore: Maryland Historical Society, 1978.

Beirne, Francis F. *The Amiable Baltimoreans.* New York: E.P.Dutton and Company, 1951.

Beirne, Francis F. *Baltimore . . . a Picture History 1858-1958.* New York: Hastings House, 1957.

Brugger, Robert J. *The Maryland Club: A History of Food and Friendship in Baltimore, 1857-1997.* Baltimore: The Maryland Club, 1998.

Clapp, Elizabeth Fisk et al. *Maryland Gardens and Houses.* Baltimore: The Barton-Gillet Co., 1938.

Dorsey, John. *Mount Vernon Place: An Anecdotal Essay with 66 Illustrations.* Baltimore: Maclay & Assoc., 1983.

Heiser, Ellinor Stewart. *Days Gone By.* Baltimore: Waverly Press, 1940.

Hoover, Ann How. *An Informal History of Pleasant Hill.* Privately published, 1987.

Simmons, George B. *A Book of Pictures in Roland Park Baltimore Maryland.* Baltimore: Norman T.A. Munder & Co., 1912.

Stevens, Barbara M. *Homeland History and Heritage.* Timonium, MD: Kwik Print, Inc., 1976

Stieff, Frederick Philip. *Baltimore Annapolis Sketch Book.* Baltimore: H.G.Roebuck & Son, 1935.

Thomas, Dawn F. *The Green Spring Valley: Its History and Heritage, Vol.I.* Baltimore: Maryland Historical Society, 1978.

Waesche, James F. *Crowning the Gravelly Hill - A History of the Roland Park - Guilford - Homeland District.* Baltimore: Maclay & Associates, 1987.

Weeks, Christopher. *Perfectly Delightful.* Baltimore: The Johns Hopkins University Press, 1999.

Worrall, Margaret, *The History of Green Spring Valley Hunt Club.* Owings Mills, MD: The Green Spring Valley Hunt Club, 1992.

INTRODUCTION

Long and widely renowned as an enclave of good taste and culture, Baltimore has, from its inception, offered a good life to those who could afford it. From hunt cups to hatpins and terrapins to top hats, Baltimoreans have been connoisseurs of the best. When life was their oyster, they knew the best way to have it served.

Please join us, gentle reader, as we perambulate amidst the prosperous. We'll catch glimpses of lives that were, in all likelihood, quite different from those we've experienced. From the dawn of the Republic to the demise of the fingerbowl, we will stroll through Society; we'll see where its members lived, shopped, worked, and played. You may be surprised at how many of their legacies still may be enjoyed today—whether they be historic homes that are now open to the public, such as Homewood House Museum or Ladew Topiary Gardens, or cultural institutions endowed by generous philanthropists that allow the many to enjoy what was once the province of the few, such as the Enoch Pratt Free Library or the Walters Art Gallery. Even the names of many neighborhoods and streets can be traced back to the old estates.

As dearly as we wish that we could cover every aspect, space does not permit, so we have selected a sampling of houses and hayfields, ladies and landmarks, clubs and culture, shops and sports. When Baltimore's first official census was taken in 1790, over 13,000 people called it home. Subsequent years brought a dramatic rise in population, particularly the years between 1830 and 1850, and the years after Reconstruction, when many impoverished Southerners made their way north (or at least this far north), in search of food for the table and a fresh start. As it transformed from a town to a city, and thence to a city with suburbs, Baltimore still retained its small-town feel in many ways. For example, some of the same customs and entertainment persist, and some of the families whose names became familiar to friend and stranger alike one or two hundred years ago still reside in the area.

As Baltimore continued to grow and expand, it absorbed some of the old estates. What had been country became city or suburb. Many of the old estates, such as Homeland, Guilford, and Woodlawn, were divided and developed as upscale residential neighborhoods. The Roland Park Company, founded in 1891, was a national pioneer in this type of development. These suburbs enabled people of means to have some of the benefits of a country estate (and its healthy environment), while being easily accessible for a daily commute to the city for businessmen. In short, they could become quarter-acre aristocrats.

The first chapter, entitled "Town and Country," showcases quite a number of houses, in both locations, many of which still stand today. A few remain private residences; others have been

turned into museums, while one now houses a popular restaurant. We will also examine what became of the property that went with these houses. Some, such as Druid Hill, became parks, while others, such as Homeland, became suburban developments. As the city grew, Baltimoreans who were able continued to move their country homes further out into the country, until transportation improvements made it possible for them to turn their summer homes into year-round homes. In addition, the advent of the streetcar, railroads, and later, automobiles, made suburbs, such as Roland Park, a viable alternative to city living.

"Clubs and Diamonds" reflects some of the schools and shops, clubs and cultural institutions, that defined and shaped these lives. Most of the clubs were founded by small groups with a shared interest. That interest could take on a wide variety of forms, ranging from sports, such as tennis, golf, swimming, or foxhunting, to amateur theatrical productions, to clubs with a patriotic or philosophical bent. There were clubs for men, clubs for women, clubs for children, and clubs for families.

Common interests linked families with their neighbors. The children attended school together and saw each other at the clubs. As they grew, the next generation tended to settle here, as well. Baltimoreans enjoy keeping childhood friends throughout their lives. These factors have helped make it a tightly knit community. Some may criticize this as being too insular, while others trumpet the benefits of a life steeped in tradition and lasting friendships.

It's important to note that virtually all prominent Baltimoreans had professional careers. For the most part, these were not the idle rich. As deeply ingrained as the drive to work and play hard was a sense of philanthropy. Perhaps the four best-known philanthropists were Johns Hopkins, George Peabody, Enoch Pratt, and Henry Walters. Their substantial legacies continue to enrich our community and challenge the current generation to emulate their generosity.

Finally, we will focus on "Fun and Games," in which we'll enjoy all sorts of amusements and entertainments from duck blinds to black tie. As with people everywhere, a variety of recreational pastimes filled the different seasons. If one were so inclined, days and evenings could be filled with sleigh rides, picnics, opera, tennis, tea dances, horse shows, regattas, cotillions, gardening, and gossip.

Although there are some aspects that quietly persist of this bygone lifestyle, most of what remains are old photographs and fond memories. Times change, fortunes fade, and new names replace the old. But rest assured that for one group or another, there will always be halcyon days in Baltimore.

One
TOWN AND COUNTRY

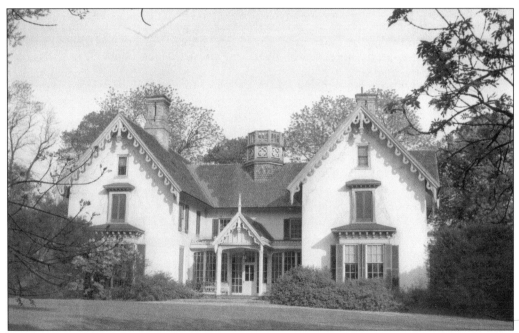

Evesham was built by Joseph Patterson, brother to Betsy Patterson. One of Baltimore's most celebrated belles, Betsy's beauty drew the affections of Jerome Boneparte, brother of Napoleon. The couple were married and settled in a house called Chestnutwood (now the Roland Park Country School), which was very near Evesham. Baltimore was scandalized when Jerome was persuaded by his brother to return to France and create a political alliance by marrying a princess. Leaving poor Betsy, Jerome sacrificed love for politics. (Courtesy Enoch Pratt Free Library.)

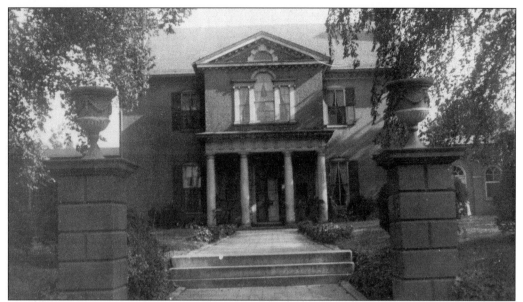

This beautiful Georgian Colonial, built by Charles Carroll, or "The Barrister," between 1756 and 1760, is the oldest house in Baltimore. Once an estate in the countryside that surrounded Baltimore Town, Mount Clare now stands like an island surrounded by an urban environment. (Photo by Richard J. Chambliss; courtesy Enoch Pratt Free Library.)

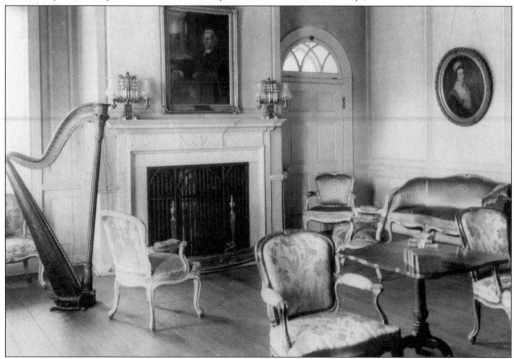

"The Barrister" (1723–1783) was the author of the Maryland Declaration of Rights. This drawing room features the portrait of "The Barrister" painted by famed portraitist Charles Wilson Peale. The house is managed by the Maryland Society of Colonial Dames and is open to the public. (Courtesy Enoch Pratt Free Library.)

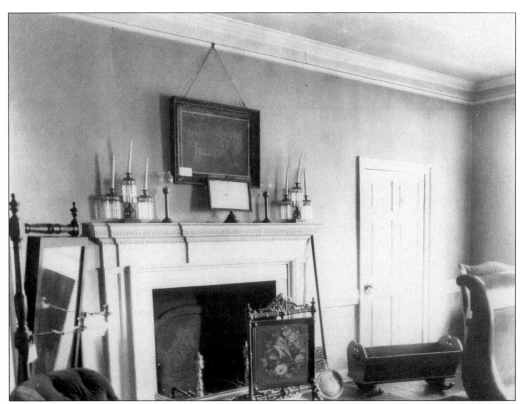

The east bedroom at Mount Clare shows the simplicity of structure and design that characterized American Colonial interior design. Note the decorative fire screen and the cradle near the hearth. Mount Clare is unusual in that most of the furnishings, donated by the Carroll family and collectors, are original to the house. This picture, taken in the 1930s, shows the beginning stages of furnishing Mount Clare. Visitors today would find much more in the way of furnishings. (Courtesy Enoch Pratt Free Library.)

Here is the approach to Mount Clare as seen from Carroll Park. The house remained in the Carroll family until 1890, when the city bought the property and used it as a park. (Courtesy Enoch Pratt Free Library.)

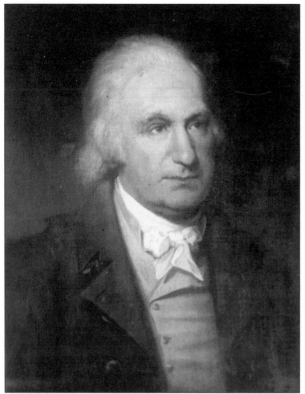

John Eager Howard (1752–1827) was a Revolutionary War hero and one of Baltimore's earliest and most illustrious citizens. Colonel Howard was the governor of Maryland from 1788 to 1791, and held a seat in the Senate from 1796 to 1803. He also owned a great deal of the land that now comprises Baltimore City, and donated a small parcel, known as Howard's Woods, as the site of the Washington Monument. (Courtesy Enoch Pratt Free Library)

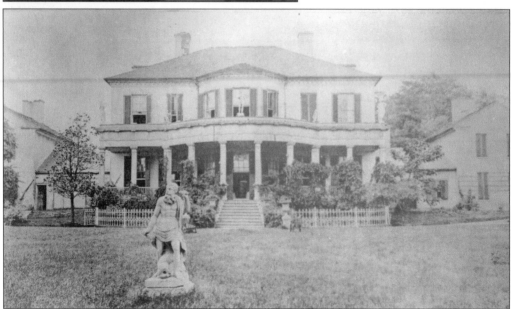

John Eager Howard's estate, Belvedere, was built in the 1780s on what is now Calvert Street just south of Chase Street. The house remained in the family until 1841. In 1875, shortly after this photograph was taken, the house was sacrificed for the growth of the city when Calvert Street was extended north. The estate lives on in the name of the gracious hotel that was built near the home's original site. (Courtesy Enoch Pratt Free Library.)

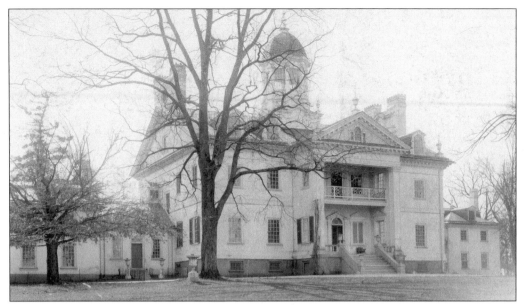

One of Baltimore's oldest families is the Ridgley family. The Ridgley landholdings reached an impressive 10,000 acres, including land that is now Guilford, Roland Park, and Homeland. Charles Ridgley built Hampton between 1783 and 1790, in what was considered at the time to be wilderness. The beautiful mansion became a center of social activity in early America and gained a reputation for gracious hospitality. (Courtesy Enoch Pratt Free Library.)

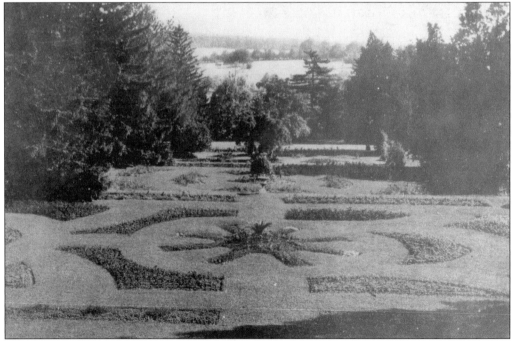

The parterre garden (a terraced garden of several levels) at Hampton was cleverly designed to be an optical illusion. From the vantage point in this photograph, the many terraces appear to be only one level. It was a remarkable feat of engineering at the time of construction. (Courtesy Enoch Pratt Free Library.)

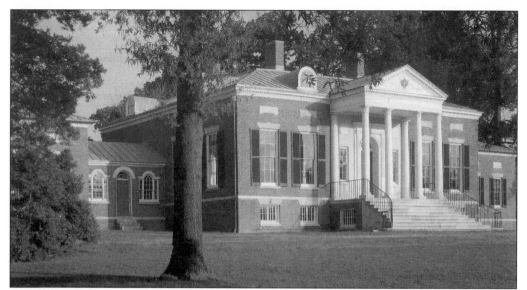

Homewood is one of the most recognized houses in our country and provides a superb example of Federal architecture. Originally the country home of Charles Carroll Jr., and his bride, Harriet Chew, construction began in 1801, lasting for several years. The land and house were a wedding present from the groom's father, Charles Carroll of Carrollton. The pater, regarded as one of the wealthiest men in the colonies, was the only Catholic to sign the Declaration of Independence. The house reflects the elegant and luxurious lifestyle led by the Carrolls, who moved in the highest levels of colonial society. Today Homewood House is a museum. Located on the campus of Johns Hopkins University, Homewood's distinctive style is reflected in some of the school's buildings, which now surround it. (Courtesy Homewood House Museum, The Johns Hopkins University.)

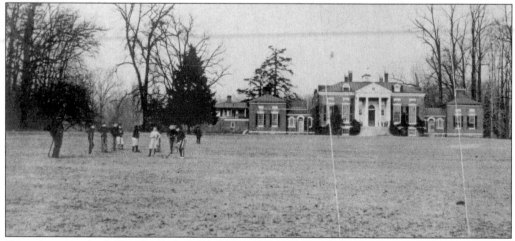

Over the years, both Homewood and Baltimore have changed. During the Carroll occupancy of Homewood, it was about an hour's carriage ride to Baltimore. Now, Homewood is within the city limits and surrounded by tall buildings and busy streets. This photograph shows Homewood when it housed the Gilman School (1897–1910). Note the additions of a dormitory, which can be seen at the far left of the building, and the cupola. Both were subsequently torn down. Of additional interest is the level playing field. Today the house crowns a gently sloping hill. (Courtesy Homewood House Museum, The Johns Hopkins University.)

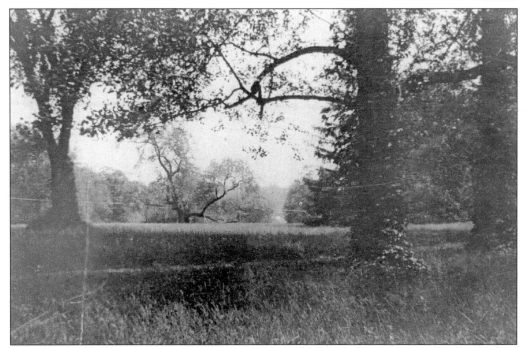

This bucolic vista is believed to be looking east from the Homewood property towards what is now Charles Street, *c.* 1906. (Courtesy Homewood House Museum, The Johns Hopkins University.)

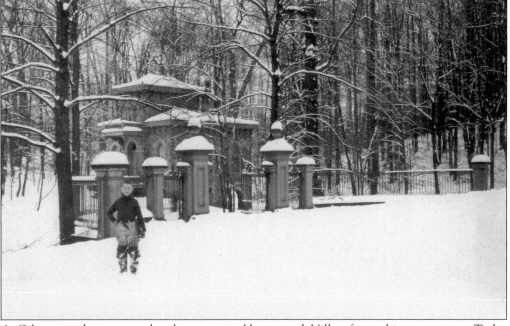

A Gilman student pauses by the gates to Homewood Villa after a big snowstorm. Today the building houses the newsletter office for the student newspaper. Charles Street runs where the photographer stood to take this shot. (Courtesy Homewood House Museum, The Johns Hopkins University.)

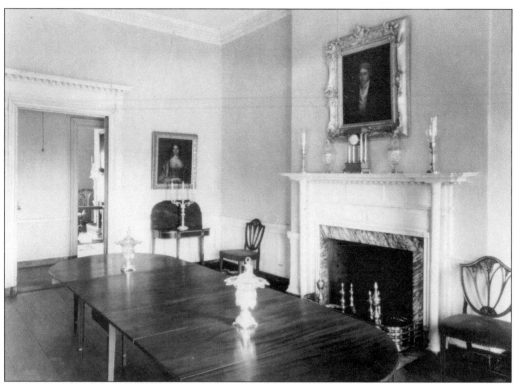

Pictured both above and below is the Homewood dining room. (Courtesy Homewood House Museum, The Johns Hopkins University.)

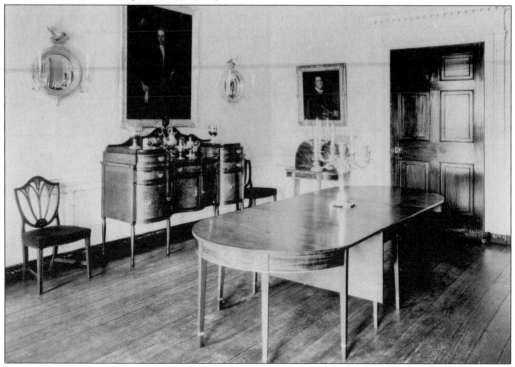

SILVER TEA SET MADE BY RICHARDSON OF PHILADELPHIA.
Owner: Miss Christiana Bond.

PAIR SHEFFIELD SILVER URNS.
Owner: Mr. and Mrs. John S. Gibbs.

INLAID CONSOLE TABLE.
Owner: Arthur E. Cole.

PORTRAIT—*Subject:* Mrs. Rebecca Ridgely, nee Dorsey, (1739-1812).
Artist: John Hesselius.
Owner: Mr. and Mrs. John Ridgely of H.

INLAID CONSOLE TABLE.
Owner: Mr. and Mrs. Bayard Turnbull.

HEPPELWHITE DINING ROOM TABLE IN THREE SECTIONS—originally in the Harwood House, Annapolis.
Owner: Mrs. and Mrs. Henry Lay Duer.

EPERGNE AND CANDELABRA.
Origin: The Greenway Estate. Said to have been brought from England by the original Alexander Brown.
Owner: Mr. and Mrs. William H. Whitridge.

PAIR WATERFORD GLASS COMPOTES.
Owner: Mr. and Mrs. Warrington Cottman.

PAIR CRYSTAL WATERFORD JARS.
Owner: Mr. and Mrs. Charles H. Baetjer.

PAIR HURRICANE GLOBE CANDLESTICKS.
Owner: Mr. and Mrs. Henry Lay Duer.

PORTRAIT—*Subject:* Charles Carroll of "Homewood," aged 22.
Artist: Rembrandt Peale.
Owner: Mr. and Mrs. Philip A. Carroll.

BRASS FENDER, ANDIRONS AND FIRE TOOLS.
Owner: Mr. and Mrs. Miles White, Jr.

OLD DAMASK CURTAINS.
Owner: Mrs. Charles F. Bevan.

In 1928, a group of area residents, who foresaw Homewood's potential as a museum, mounted the "Friends of Art" exhibition. Many local families graciously loaned the furnishings seen on these pages. These efforts were the genesis of the current museum. (Courtesy Homewood House Museum, The Johns Hopkins University.)

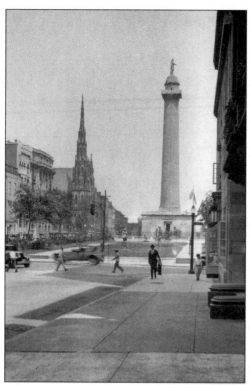

It is said that when the monument to the Father of our Country was erected, planners put it out in the country for fear of its toppling over. Whether or not that tale is true, the site chosen was on property belonging to John Eager Howard, called Howard's Woods. A friend of Washington's, Howard donated the land, and Charles Ridgley donated the marble for the base.

Due to the challenges of fund-raising and the War of 1812, it took 12 years to complete the monument. The four squares that radiate from its base, known as Mt. Vernon Place, became frontage for some of the most gracious residences in Baltimore. (Photo taken by Francis E. Old Jr.; courtesy Enoch Pratt Free Library.)

East Mount Vernon Place is pictured here in 1939. Note the gardener edging the grass. . (Courtesy Enoch Pratt Free Library.)

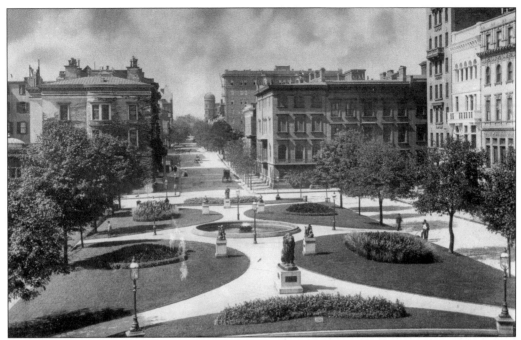

West Mount Vernon Place is seen here in 1914. Henry T. Walters had given the bronze statues. In the distance, one can see the round dome, which was the Hopkins Observatory. (Courtesy Enoch Pratt Free Library.)

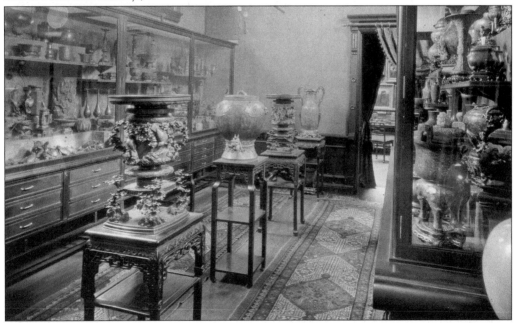

This is the interior of Henry Walters's home at 5 West Mount Vernon Place. The exotic collection displayed in the home of Mr. Walters was accumulated during frequent trips abroad. Rather than limiting themselves to fine art, Mr. Walters and his father, William T. Walters, (who collected as well) had an eye for pieces that held archeological importance. (Courtesy Enoch Pratt Free Library.)

19

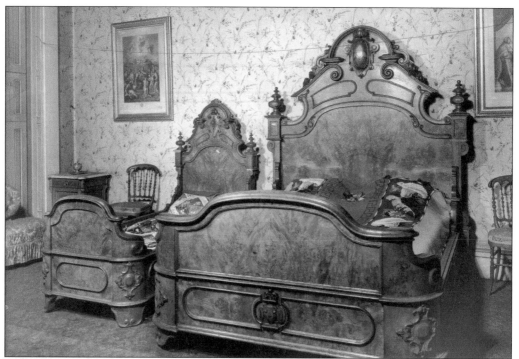

This bedroom at 5 West Mount Vernon Place reflects a Victorian sensibility. The small bed placed next to the larger one would allow a nurse or anxious mother to remain with an ailing child throughout the night in relative comfort. (Courtesy Enoch Pratt Free Library.)

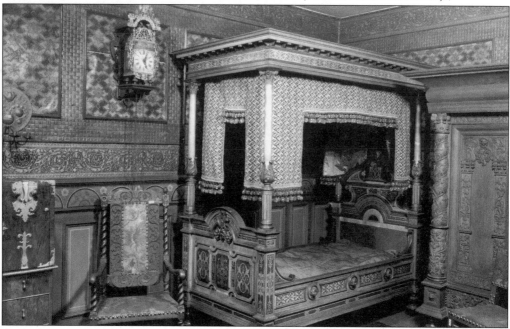

A bedroom at the Walters family home, decorated with Elizabethan furniture and intricate motifs and patterns, illustrates the eclectic tastes of the family. (Courtesy Enoch Pratt Free Library.)

The Perine's home at 607 Cathedral Street was originally purchased by David M. Perine in 1864. Several members of the Perine family owned homes in town, some only a block or two away from one another. The Perines would reside in town in the winter months and then travel out to their country estate, known as Homeland, for the summer. (Courtesy collection of Mr. and Mrs. Allan Mead.)

This elegant dining room table, set for 15, is ready to receive guests for Christmas dinner. The diners might have been served oysters, terrapin, wild turkey, or canvasback duck, all Maryland delicacies. Many Baltimore families tell hilarious stories of the challenges of preparing terrapin, not the least of which was the effort required to corral live turtles into a pot! (Courtesy collection of Mr. and Mrs. Allan Mead.)

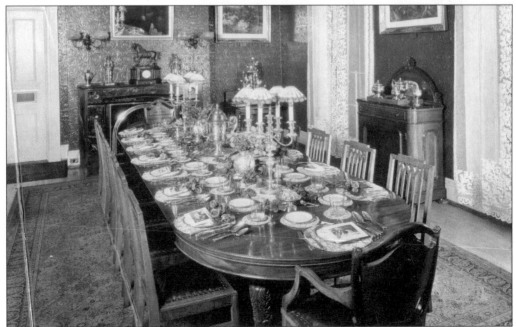

Patrons of the Brass Elephant, a stellar restaurant located at 924 Charles Street, will recognize some of the scenes in this section of photographs. Built in 1850 by a member of the respected Howard family, the home was eventually sold to George Wroth Knapp in 1870. This prosperous merchant invested about $100,000 to transform his townhouse into a showplace of Gilded Age grandeur. Used primarily as a weekday residence by Mr. Knapp, it lacked none of the amenities of his luxurious home in Catonsville, which is now Catonsville Community College. A popular decorating motif of the late nineteenth century is seen in the intricately carved teak, which graced both the hallway and what is now the middle dining room. Teak handcarved by Moroccan craftsmen and augmented by potted palms and Persian carpets enhance the exotic effect. The restaurant was named for the brass elephant sconces, which are pictured along the right wall. (Courtesy The Brass Elephant.)

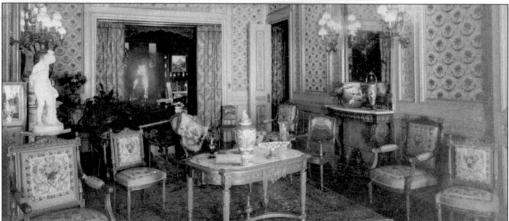

In the drawing room one can imagine important personages being entertained and witty repartee being tossed back and forth, all the while precariously perched upon petit point chairs. In addition to fine porcelains, carved marble, and gold-leaf framed mirrors, the house boasted a number of original Tiffany stained-glass windows, including a spectacular skylight. The luxurious, and frequently fragile, nature of the room's furnishings probably helped ensure everyone's best behavior. (Courtesy The Brass Elephant.)

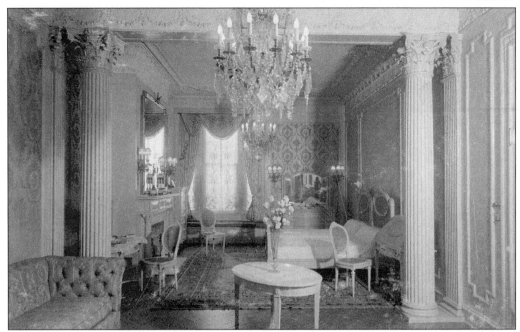

As was often the custom during the Victorian and Edwardian eras, husbands and wives of means maintained separate bedrooms. Mrs. Knapp's bedroom and boudoir were connected by pocket doors to her husband's room. The Waterford chandeliers throughout the house, as well as the brass elephant sconces were originally designed for oil or gas. They were later converted to electricity. Note the Corinthian columns, ornate molding, carved mantel, and delicate furniture. It could be the setting for a scene from an Edith Wharton novel. (Courtesy The Brass Elephant.)

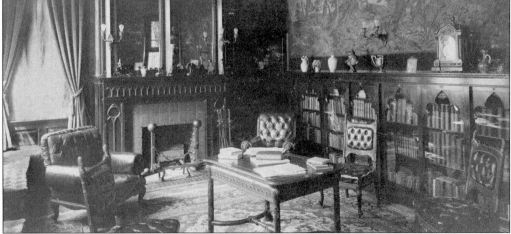

The library featured glass-fronted bookcases (less dust for the downstairs maid) and leather chairs. Note the woodland mural above the bookcases. The Knapps invested much of their time, taste, and money in their house. When the family finally sold the house to the Pothast Furniture Company, it was used as a showroom. (Their tenure is reflected in the large picture window installed for shoppers.) Should the Knapps reappear today, they would recognize much of the basics. Aside from the fact that the building houses a restaurant, and cosmetic changes have been made here and there, it remains much the same. (Courtesy The Brass Elephant.)

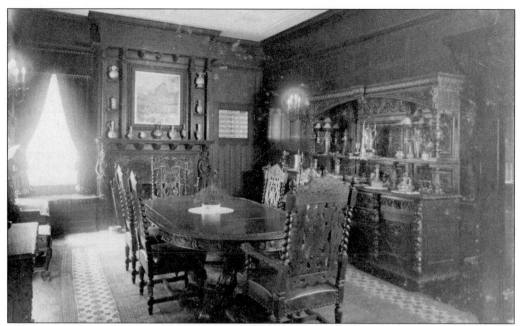

The former Knapp house consists of four stories. The first floor was composed, in part, of public rooms, such as the dining room, conservatory, and drawing room. Apart from Mrs. Knapp's bedroom, they were the most elegantly appointed rooms. The second floor included Mr. and Mrs. Knapp's sleeping suites, as well as a study and library. The third floor consisted of bedrooms for children and guests. While servants slept on the fourth floor, a nanny, governess, or tutor would typically be housed on the third floor, along with their charges. Baltimore is known for its hot and humid summers, and one of the decorative features of the home, a stained glass dome, also provided a primitive cooling system. (Courtesy The Brass Elephant.)

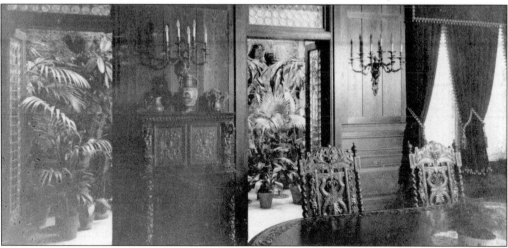

Every house of substance had a conservatory—this one may be glimpsed through the open doorways of the dining room. It provided a bright and light contrast to the dark and heavy feel of the oak-paneled dining room. Notice that even the edge of the dining table is elaborately carved. The glasswork over the doorways (as well as the almost unseen open doors themselves) is called "bulls-eye." The frame holds many pieces of glass that are individually encased in lead. It is yet another example of the opulent atmosphere. (Courtesy The Brass Elephant.)

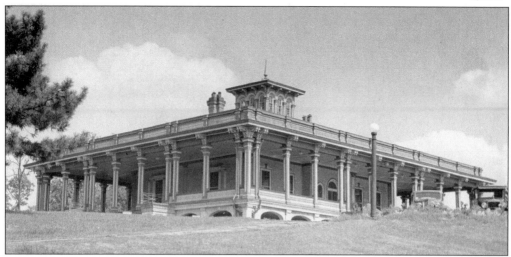

Visitors to the Baltimore Zoo or picnickers enjoying Druid Hill Park are probably unaware of its history. In 1716, an innkeeper named Nicholas Rogers purchased part of the original 12,000-acre grant made in 1688 from Lord Calvert to a Mr. Richardson. Over the years, there were several houses located on the property, the last of which is seen here. This Italianate mansion called Druid Hill was built by the Rogers family. They sold the property in 1860, and Druid Hill Park was created. It boasted a zoo, botanical gardens, bandstand, gazebos, and a lake for boating. Once surrounded by fashionable neighborhoods and a haunt of society, the park has been enjoyed for generations by people from all walks of life. (Courtesy Enoch Pratt Free Library.)

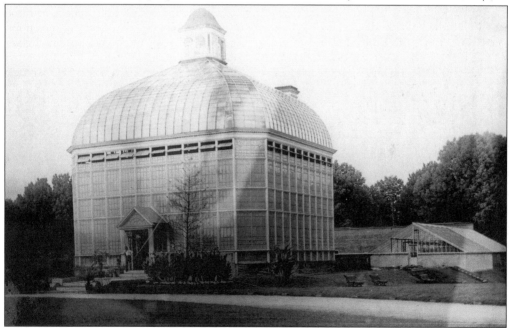

The exquisite glass conservatory in Druid Hill Park is an example of the elaborate greenhouses built in the Victorian era. Built by Baltimore City's Park Commission and designed by George Frederick (architect of Baltimore's City Hall) the ornate structure has 175 windows—many of them curved! Baltimore residents could enter the artificial climate and enjoy exotic plants they would otherwise never have seen. (Courtesy Enoch Pratt Free Library.)

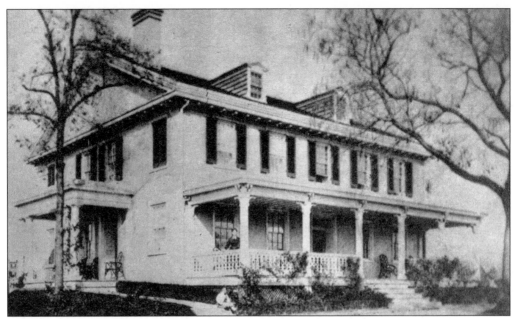

The Denmead family owned land stretching from Twentieth Street (formerly known as Denmead Street) to the Jones Falls (near Penn Station). This lovely home, built in the 1700s, was used as their country home. Demolished in 1883, Lafayette Avenue now runs through the site. One of the modern conveniences featured on the estate was an automatic gate, which was activated by approaching carriages. An interesting real estate footnote concerns Talbot Denmead, who donated the land for St. Michael and All Angels Church, located at Twentieth Street and St. Paul; the deed specified that the land would return to his heirs if it was no longer used as an Episcopal church. (Courtesy collection of Hildegarde Denmead LeViness.)

Bolton Hill was another of Baltimore's affluent urban neighborhoods. This 1936 view of the 1200 block of Mount Royal Avenue shows the tidy but elegant town houses that line the shady streets. A stroll on stately Eutaw Place instantly transports one back to the late 1800s. (Courtesy Enoch Pratt Free Library.)

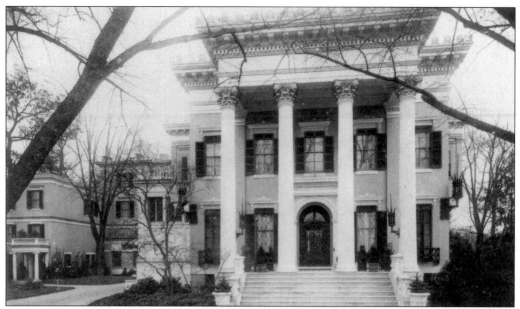

The Corinthian columns supporting Evergreen's Italianate portico would immediately alert a visitor that this was no ordinary home. Though it was Stephen Broadbent who built the house in 1858, Evergreen is inextricably linked with the Garrett family. John W. Garrett, president of the Baltimore & Ohio Railroad, bought the house in 1878 for his son T. Harrison Garrett. Evergreen has had extensive renovations and additions since this 1896 view. Over the years, various members of the Garrett family have added diverse features such as a bowling alley, dining room, and, perhaps most impressive, the world-renowned library. Avid collectors, the Garretts enhanced Evergreen's architectural beauty by filling it with objects of aesthetic and intrinsic value, as well as intellectual importance. Now under the auspices of the Johns Hopkins University, Evergreen is open to the public. (Courtesy collection of the Evergreen House.)

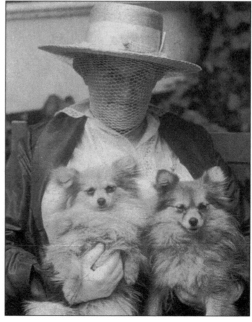

This is a portrait of Alice Whitridge Garrett, the first mistress of Evergreen, with her beloved Pomeranians. A devoted mother, she accompanied her sons to Princeton when they attended the university there; an arrangement that might be regarded as unusual today. (Courtesy collection of the Evergreen House.)

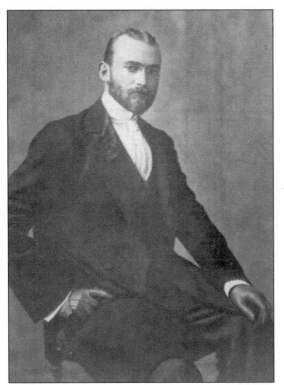

John Work Garrett (1872-1942) spent his childhood at Evergreen until his father drowned in an accident on the Chesapeake Bay. After this tragic event, Garrett traveled with his bereaved mother and two younger brothers throughout Europe and the Near East. It was perhaps at this time that Garrett acquired an interest in international affairs. A few years after graduating from Princeton, Garrett joined the Foreign Service. During his tenure in Berlin, he met his future bride, Alice Warder. Garrett continued his diplomatic career until his mother's death in 1920. Returning to Evergreen, Garrett and his wife, Alice Warder, benefited Baltimore society with their active patronage of the arts and their intellectual pursuits. (Courtesy collection of the Evergreen House.)

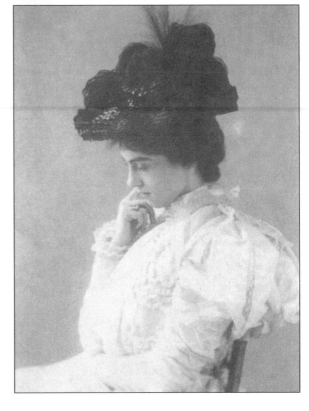

Alice Warder Garrett, originally from Washington, D.C., was studying voice in Berlin when she met her husband, John W. Garrett. After traveling to various diplomatic posts, no doubt absorbing the best each city had to offer, the couple returned to Evergreen. Known for her bohemian flair, Alice was a vigorous supporter of the arts and was renowned for her hospitality. She opened her home to artists as well as friends, such as Harvey Ladew and Mr. and Mrs. Jack Symington. An evening at Evergreen would provide Baltimore society fixtures with the opportunity to mix with giants in the literary and art world. (Courtesy collection of the Evergreen House.)

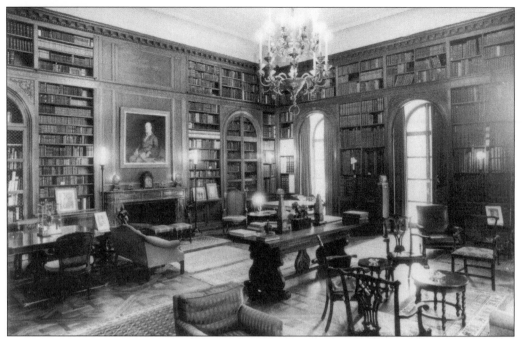

The Garrett's extensive collection of books compelled them to build an addition in 1927. The Great Library, paneled in walnut, provides a beautiful and serene setting for over 8,000 volumes. (Courtesy collection of the Evergreen House.)

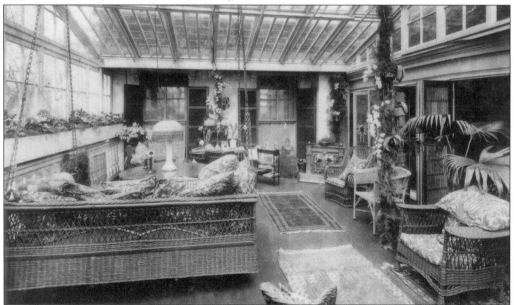

This remarkable conservatory at Evergreen is no longer a feature of the house, but it was a lovely example of the value placed on leisurely conversation and the enjoyment of natural beauty. It is hard to imagine anything more ambitious than the pursuit of a good book or a quiet talk taking place here. With the expansive glass ceiling, this room was a dose of summer on a cold day, but it could not have been too attractive in August! (Courtesy collection of the Evergreen House.)

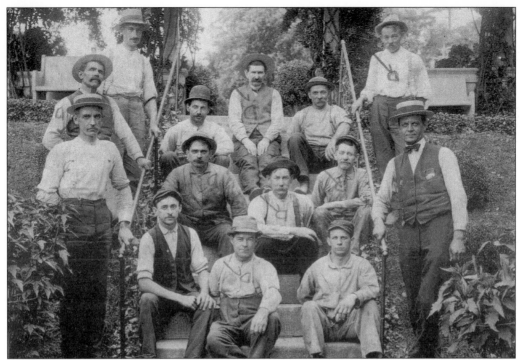

The beautiful gardens and grounds that surrounded the area's illustrious houses would not have been possible without the efforts of highly skilled groundskeepers and gardeners. In many cases, these men would have had extensive training in various horticultural disciplines; that, combined with experience, made them indispensable to their employers. This group poses on the grounds of Evergreen, c. 1919. (Courtesy collection of the Evergreen House.)

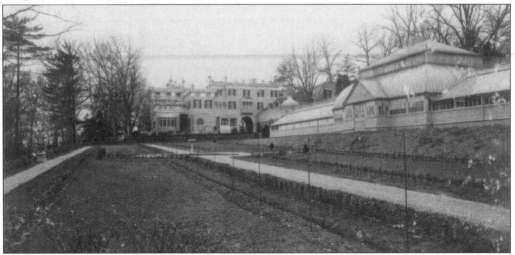

These greenhouses were built in 1885 by T. Harrison Garrett. Built as a series of seven houses, they provided for the cultivation of orchids, ferns, palms, various fruits and vegetables, and there was even a mushroom pit! The Garretts were able to provide their guests with fresh food, out of season; this was a real luxury at a time when importing fruits and vegetables from a warmer climate was difficult. In the 1920s, John and Alice Garrett added a formal Italian garden, additional flowerbeds, and boxwoods. (Courtesy collection of the Evergreen House.)

What once looked like a quiet country road is now busy Wyndhurst Avenue. This eastern view looks toward what is now Charles Street. When this photo was taken, it took about a half hour to travel downtown—much the same as today, depending on the traffic! (Courtesy Mrs. William H.C. Wilson.)

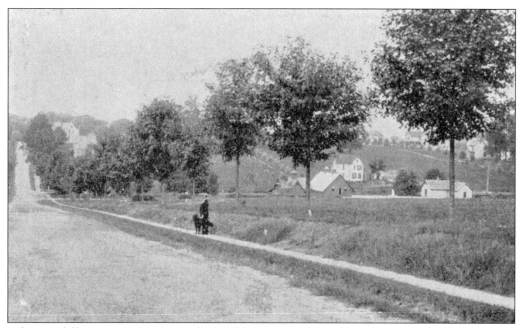

What a difference a century makes! This view of Wyndhurst Avenue faces west. The Wyndhurst Station shopping center is now located at the bottom of the hill. Its site was formerly a train station (hence its name), which hasn't even been constructed when this shot was taken! (Courtesy Mrs. William H. C. Wilson.)

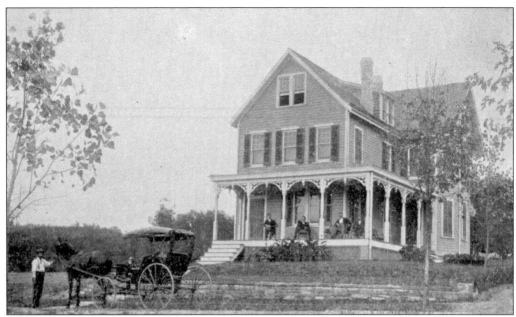

This home was located on Wilson Avenue, which is now known as Boxhill Lane. Nestled next to Roland Park, the development known as Embla Park offered home mail delivery four times daily, along with other inducements. (Courtesy Mrs. William H.C. Wilson.)

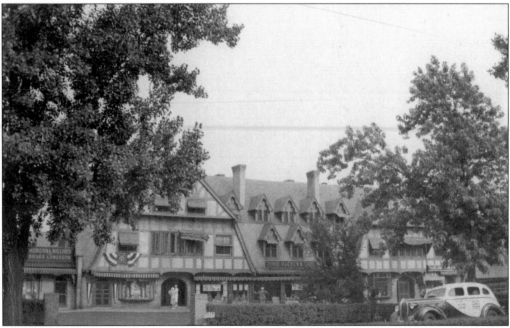

Roland Park residents were, no doubt, grateful for the convenience of a local shopping center, the first of its kind. Originally intended as a community center, the planners realized shops were desperately needed in the far-flung neighborhood. Shopping at Victor's and enjoying a malt at the counter in Morgan Millard's was a part of everyday life for Roland Park residents. It is hard to believe that this charming Tudor-style building was the forerunner to the enormous malls that dot American suburbs today! (Courtesy Enoch Pratt Free Library.)

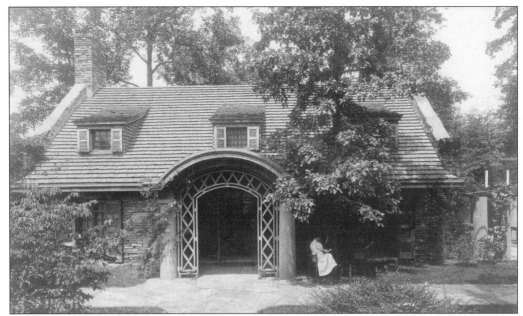

Rusty Rocks, the home of Roland Park's developer Edward Bouton, is frequently referred to as the area's masterpiece. The charming stone cottage was actually rather small, with only two bedrooms, but when built in 1907, it did boast teak floors, beamed ceilings, oak walls, and a music room. The spectacular grounds added to the desired effect that one was living in an Arcadian setting in harmony with nature. (Courtesy Mrs. William H.C. Wilson.)

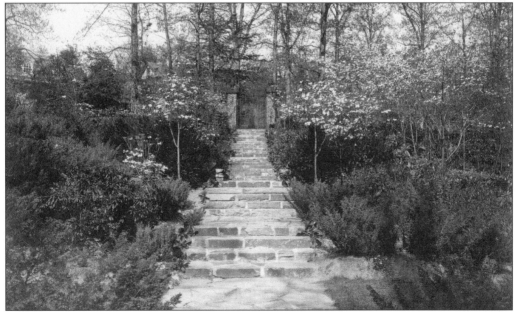

This photograph, taken in April 1912, shows the charming walk leading from Club Road down to Edward Bouton's beloved Rusty Rocks. Nestled next to Baltimore Country Club and hidden by a gate, wall, and plantings, the home is well hidden from prying eyes. Under Bouton's careful supervision, the grounds boasted a gazebo, footbridges and fountains, pathways and ponds, walkways and waterfall. (Courtesy Mrs. William H.C. Wilson.)

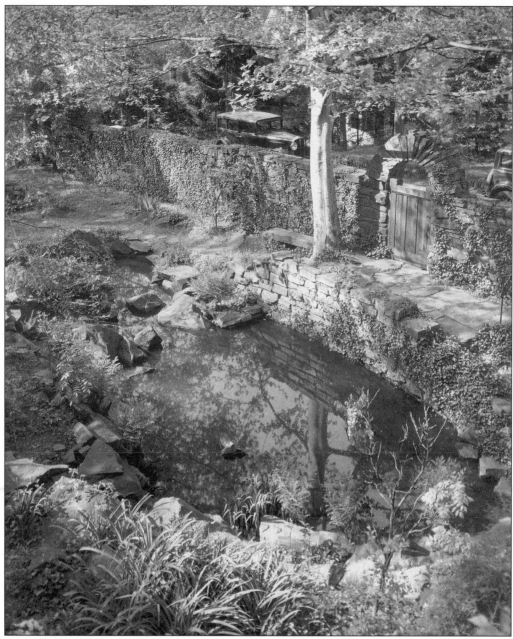

Rusty Rocks has been enjoyed not only by its series of owners but also by its many guests and visitors. When Yellow Cab Company owners Mr. and Mrs. W.W. Cloud owned the house, they were renowned for their extravagant entertainments, which were frequently held outdoors. They outdid themselves when they threw a golden wedding anniversary party for themselves. Hundreds of guests were entertained by an organ recital, operatic arias, and a performance by the Baltimore Ballet. (Courtesy Mrs. William H.C. Wilson.)

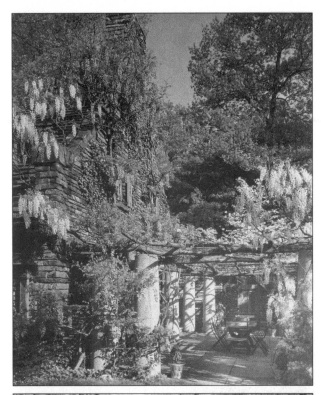

As difficult as it is to believe, this sylvan setting was once a source of consternation for Roland Park's developers. Originally a quarry, complete with "rusty" rocks, it is situated right in the middle of what was being transformed into one of America's loveliest addresses. In a shrewd stroke of marketing, Edward Bouton proclaimed that he would make the unsightly property his home. In a bit of bravado, his wife chimed in that they would even call it "Rusty Rocks." Working in part with the peerless Frederick Law Olmstead, the site was transformed into the development's crowning achievement. (Courtesy Mrs. William H.C. Wilson.)

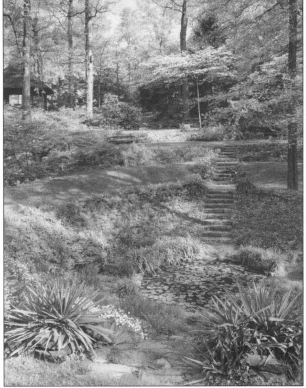

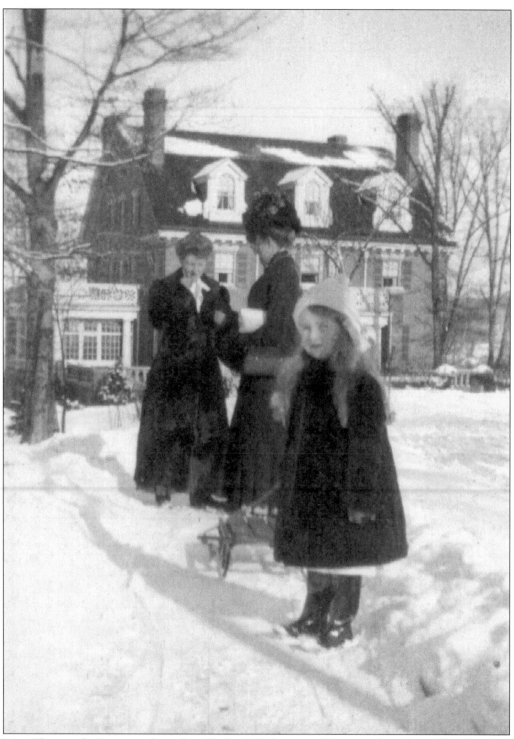

Mrs. Thomas de Rosset and another "Roland Park matron" have a chat along Club Road in Roland Park, while Ida de Rosset waits patiently to go sledding. We wonder if she is brave enough for the steep hills along Club Road. (Courtesy Mr. and Mrs. Hal C. Whitaker.)

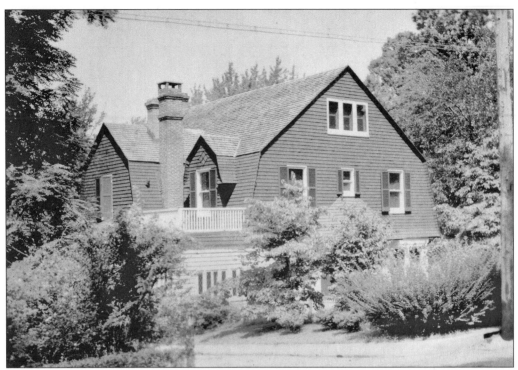

Roland Park is admired for its winding ways and shaded streets. This shingle-style home, located on Oakdale Road, is a wonderful example of the earliest homes built in Roland Park. Many of the later houses featured Italianate, neo-Colonial, and Tudoresque styles. (Courtesy collection of Hildegarde Denmead LeViness.)

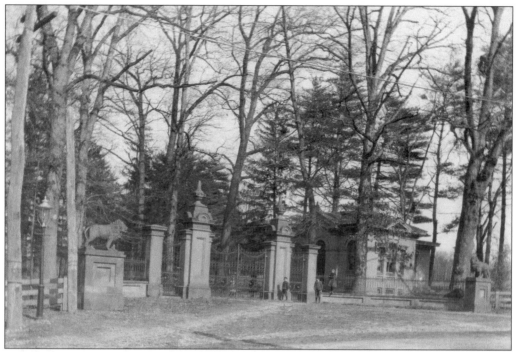

These formidable gates stood at the York Turnpike entrance to the Guilford Estate. (Courtesy Enoch Pratt Free Library.)

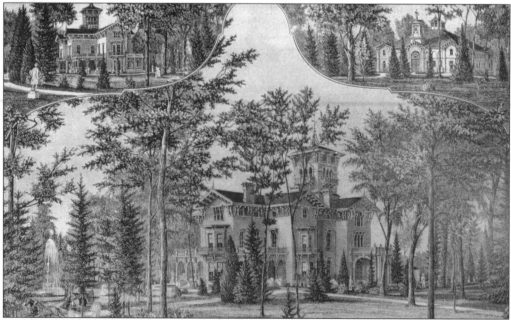

Guilford was built in the 1850s by William McDonald. Arunah S. Abell, founder of the *Baltimore Sun*, purchased the Italianate mansion and 300 acres from McDonald's descendants. The house remained in the Abell family until 1907, when it was sold for one million dollars to the Roland Park Company. The estate was carved into large lots, but Guilford lives on in the name of the elegant and stately neighborhood. (Courtesy Enoch Pratt Free Library.)

Sherwood house and gardens are the best-known landmarks in Guilford. The house was modeled after the famous house at Shirley Plantation in Virginia and built by John R. Sherwood, who extensively landscaped and planted the grounds. Upon his death, the gardens were given to the city. They provide a source of pleasure to countless numbers of visitors and residents alike, who come to enjoy the beautiful flowerbeds and plantings. The most popular time to visit is in the spring when all the beds are ablaze with different colored tulips. (Courtesy author's collection.)

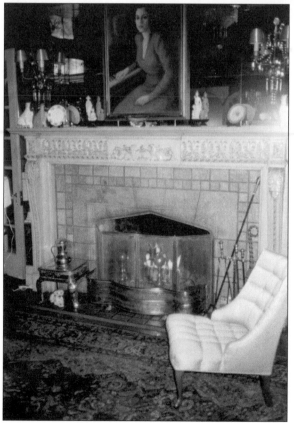

Built in 1929, the interior of this Guilford home epitomizes Art Deco elegance. The softly lit and mirrored living room, replete with its ornately carved mantelpiece, provides one of the most romantic and elegant settings imaginable. The portrait is of the lovely Sarah S. Buckingham, who for many years hosted delightful gatherings that displayed her home to its best advantage. The matching porches feature painted ceilings and unusual tiled floors. Its gracious interior combined with the beautifully planted grounds help show why Guilford is still a much sought-after address, almost a century after its development. (Courtesy Bill Buckingham.)

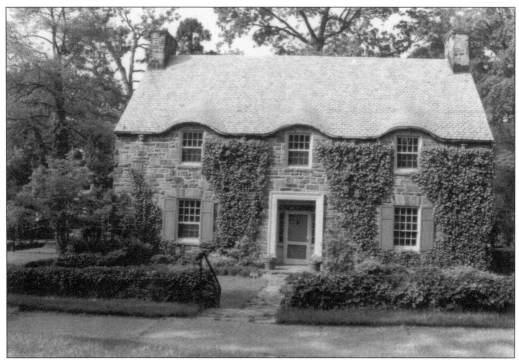

Guilford, Roland Park, and Homeland are all known for their English feel. Many of the roads have English names, and much of the architecture, plantings, and gardens reflect this Anglophilia. This charming ivy-covered stone house, with its rippled slate roof and beautiful garden, would make any Englishman feel at home. (Courtesy author's collection.)

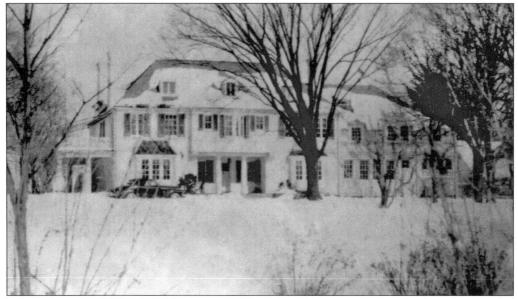

Baltimore is justifiably admired for gracious homes, such as this one. Perched in the center of Murray Hill Road, "Zappfstead," as it was long called, boasted 11 bedrooms and 6 fireplaces. An unusual feature was a large laboratory, located in the cellar, which was used during World War II. (Courtesy author's collection.)

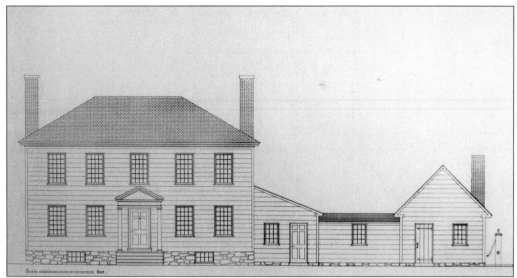

"Job's Addition," a 150-acre parcel, was, by today's definition, bounded by Northern Parkway, Charles Street, Homeland Avenue, and Springlake Way. The property passed through the hands of many Maryland family names, such as Merryman, Hopkins, and Ridgley. In 1799, Hephzibah Perine Buchanan sold 1/3 of the property to her son David M. Perine for $450. Perine purchased the remaining 150 acres from his half-brothers and renamed the estate "Homeland." The house, built sometime before 1797, served as Perine's summer residence until he razed it and built a second, more elegant home. (Courtesy collection of Mr. and Mrs. Allan Mead.)

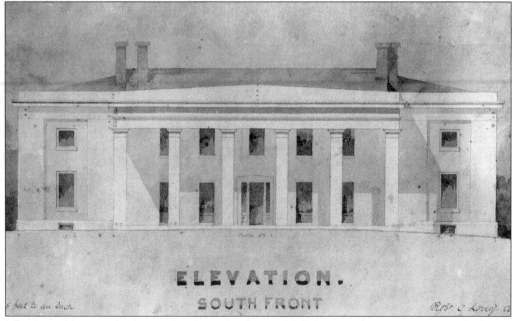

ELEVATION.
SOUTH FRONT

The second house, also known as "Homeland," was built by David Perine in 1839. The house was situated on what are today the twin circles on St. Albans Way. Unfortunately, the house burned to the ground on a March night in 1843. As the house was unoccupied at the time, arson was suspected to be the cause. (Courtesy collection of Mr. and Mrs. Allan Mead.)

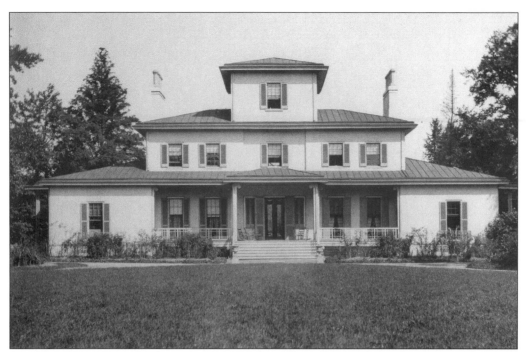

David M. Perine built this house in 1846 on the same site as the house lost to fire three years prior. The house, boasting hot and cold running water, was the Perines' summer home for several generations. (Courtesy collection of Mr. and Mrs. Allan Mead.)

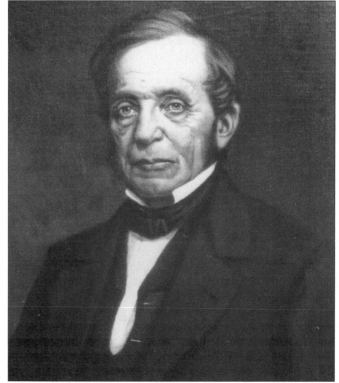

David M. Perine (1796–1882) lived the life of a businessman in Baltimore during the winter,and the life of a country gentleman during the summer months at Homeland. Mr. Perine was a prosperous man and managed his affairs exceedingly well, but he revealed his mischievous streak, when he would hide the clothes of boys skinny-dipping in the lakes he had built. (Courtesy collection of Mr. and Mrs. Allan Mead.)

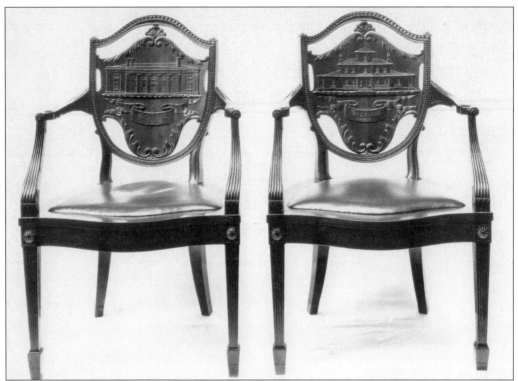

Virtually all of the wood furniture at Homeland was carved by a master carpenter on the estate. The wood came from the apple orchard, which was cut down in 1854 to make way for the northern extension of Charles Street Avenue. The wood was milled and then stored for later use. These two applewood chairs, which currently reside at the Maryland Historical Society, are decorated with carved backs representing the two houses built by David M. Perine on the "Homeland" estate. (Courtesy collection of Mr. and Mrs. Allan Mead.)

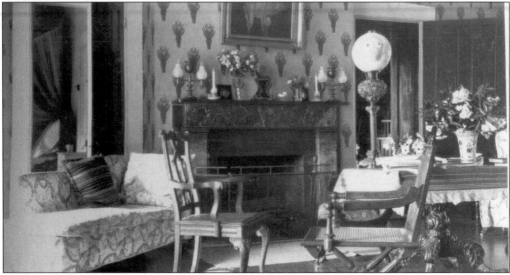

Here is the parlor at Homeland as it appeared in 1903. (Courtesy collection of Mr. and Mrs. Allan Mead.)

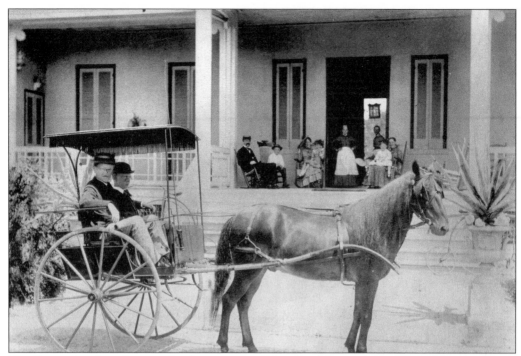

The Perine family gathers on the front porch of Homeland in 1883. Seated in the pony cart are young David and Washington Perine. On the porch are, from left to right, Glenn Perine (David M. Perine's son, who owned Homeland from 1882 until his death in 1922), George C. Perine, Mary Perine, Mildred Perine, Nurse Rebecca Graham, her daughter Tilly Graham, Annie Perine, and Mrs. Eliza Perine. (Courtesy collection of Mr. and Mrs. Allan Mead.)

Elias Glenn Perine (1829–1922) inherited Homeland from his father, David M. Perine, in 1882. Elias took a great interest in improving the estate's natural beauty, planting ornamental and shade trees as well as meticulously maintaining the paths throughout the park-like property. (Courtesy collection of Mr. and Mrs. Allan Mead.)

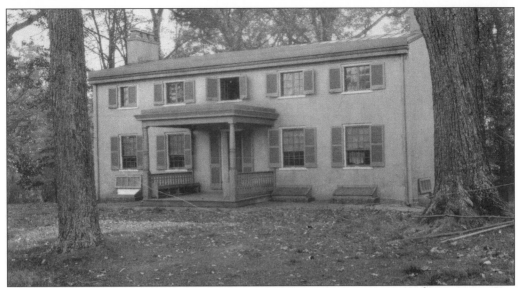

The manager's house, built in 1840, is the only building original to Homeland that still stands. Located at the corner of what is now Upnor Road and St. Albans Way, the house is now a private residence. The Perines had expanded the estate to 400 acres, so a manager was essential to run a smooth operation, particularly since the Perines lived in the city during part of the year. David Mullen, the last manager of Homeland, oversaw the dairy, the quarry, all livestock, and the crops. When the estate was sold, Mr. Mullen moved to his own farm. (Courtesy collection of Mr. and Mrs. Allan Mead.)

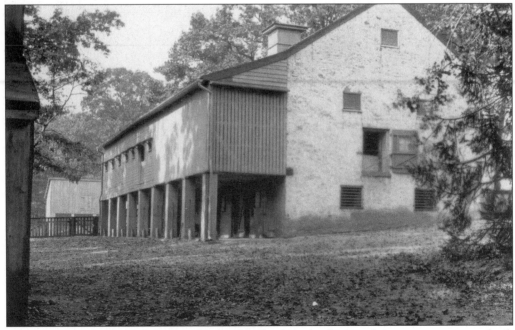

The barns stood near what is now the first block of Tunbridge Road. It is interesting to think that the backyards of a peaceful neighborhood were once pastureland for David M. Perine's herd of Durham cattle. (Courtesy collection of Mr. and Mrs. Allan Mead.)

The breathtaking vista from the front porch of Homeland leads the eye south down what is now St. Albans Way. (Courtesy collection of Mr. and Mrs. Allan Mead.)

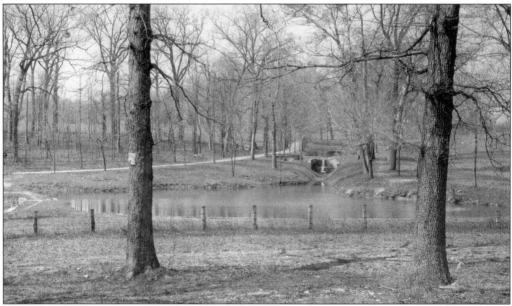

These three lakes, known as the "banjo lakes" were part of an elaborate system that provided water for Homeland. After the estate was developed, the lakes became highly decorative features of the neighborhood. Perine would be deeply gratified to see that his ponds continue to provide a delightful gathering place for the neighborhood. The path on the left of the ponds approximates what is now St. Dunstans Road, near the intersection of Purlington Way. (Courtesy collection of Mr. and Mrs. Allan Mead.)

A sign erected on the east side of Charles Street Avenue in 1923 advertised "Land For Sale." After the death of Elias Glenn Perine in 1922, his seven children, represented by brother Washington, sold Homeland to the Roland Park Company, which repeated its success developing the estate into a gracious new neighborhood in Baltimore City. Among the variety of architectural styles, are Colonial, Tudor, and French Chateau houses. The streets in Homeland are named for small villages in the English countryside. (Courtesy collection of Mr. and Mrs. Allan Mead.)

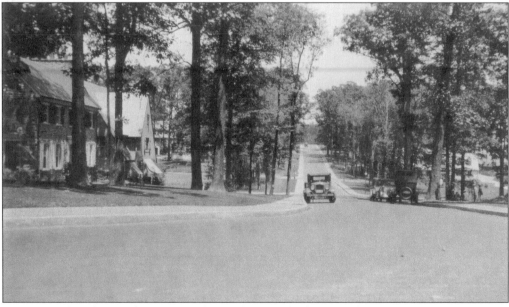

Five years after the first houses were built, the view looking north from St. Albans Way and Paddington Road looked remarkably similar to the same scene today. The tall hardwoods, many of which were planted by Glenn Perine, still stand today in silent testimony to the estate, which gave Homeland its congenial name. (Courtesy collection of Mr. and Mrs. Allan Mead.)

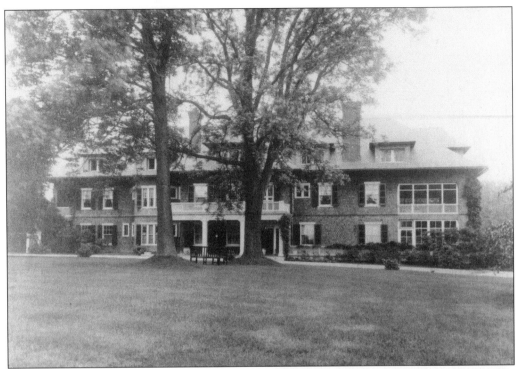

Originally a simple farmhouse, the Jenkins
family transformed Windy Gates to this
grand shingle-style house. The gardens were
reputed to be some of the finest in Maryland.
At the time of this photograph, Windy
Gates was owned by Joseph W. Jenkins Jr.
Located on Lake Avenue, the house
remained in the family until it was
transformed again in the 1980s, into the
luxury condominiums known as Devon Hill.
(Courtesy collection of Dr. and Mrs. Charles
O'Donovan III.)

The Jenkins children gather on the front
steps of Windy Gates. Without television,
videos, or computers, children had to make
their own fun. It looks as if the Jenkins
children had been putting on some sort of
entertainment, but what the bottle was for,
we shall never know. (Courtesy collection of
Dr. and Mrs. Charles O'Donovan III.)

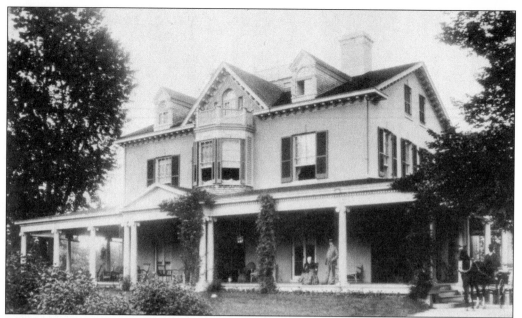

In 1882, Mr. and Mrs. Michael Jenkins purchased this estate on West Lake Avenue. The lovely home boasted a hospitable wrap-around porch and lovely gardens. The Jenkinses added garages and a small chapel in the garden, where Cardinal Gibbons once celebrated mass. (Courtesy collection of Dr. and Mrs. Charles O'Donovan III.)

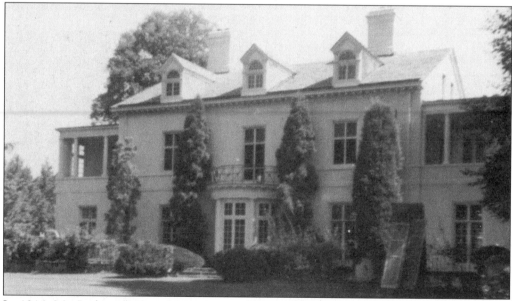

In 1914, Mr. Jenkins died, and his niece and her husband, Mr. and Mrs. J. Crossan Cooper, inherited Llewellyn. The couple made several changes. Most notable were the changes made in 1929, which altered the appearance of the house's exterior. The porch was removed and the front entrance was shifted from the south of the house to the east. Upon Mr. Cooper's death in 1959, the Boys' Latin School purchased the entire property. After the necessary renovations were made, the school opened at its new location in September 1960. (Courtesy collection of Dr. and Mrs. Charles O'Donovan III.)

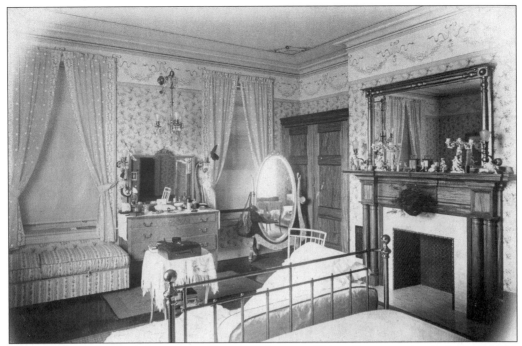

This child's bedroom, belonging to Eleanora Cooper of Llewellyn, was simple but pretty by today's standards. With the fireplace, brass bed, and decorative walls and ceiling, it was rather more elegant than the rooms of most American children in the latter part of the nineteenth century. (Courtesy collection of Dr. and Mrs. Charles O'Donovan III.)

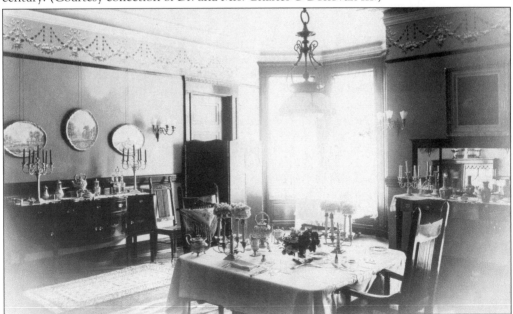

The table is neatly set in Llewellyn's breakfast room. Large houses of this time often had separate dining rooms for each meal, allowing for both intimate family settings like this one and for more formal gatherings when entertaining guests. (Courtesy collection of Dr. and Mrs. Charles O'Donovan III.)

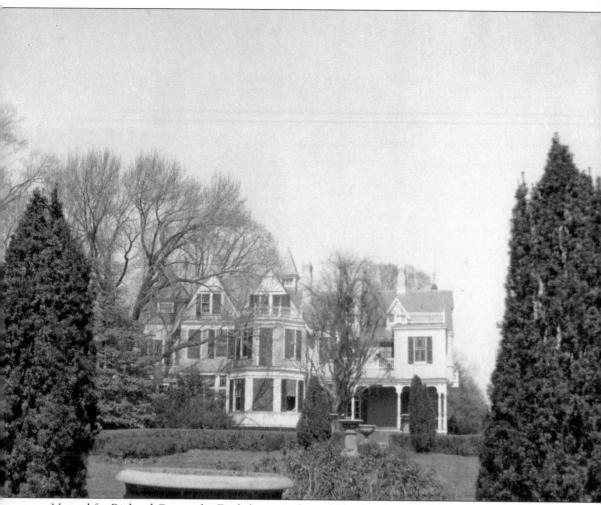

Named for Richard Caton, the English son-in-law of Charles Carroll of Carrollton, Catonsville remained a quaint village until the Baltimore and Catonsville Passenger Railway made the area an easy trip from the city. In the 1870s and 1880s, Catonsville became a magnet for prominent Baltimoreans who wanted to build summer homes (usually of generous proportions). The summers in the city were particularly unhealthy in those days, and those who could afford to do so would move their household (staff, silver, china, and linens included) to country homes. Some of the well-known family names of those who settled in Catonsville, were the Glenns and the Lehrmans. The Lehrman estate, "Farmlands" was known for its beautiful terraced garden. This estate, called Uplands, was located on Old Frederick Road, near Swan Avenue. It was bequeathed to the Episcopal Diocese of Maryland to become a home for "elderly ladies in reduced circumstances." (Courtesy Enoch Pratt Free Library.)

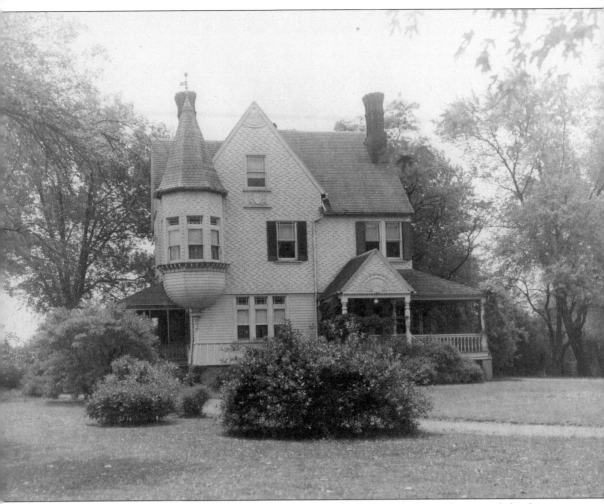

Property values in Catonsville increased exponentially in the 1880s, and some of the large estates were carved up for "smaller" houses. The Catonsville Casino (later the Catonsville Country Club) was a club that provided a focal point for Catonsville's growing population. This Victorian, located at the southeast corner of Frederick Road and Sanford Avenue, was typical of the lovely summer homes built at this time. (Courtesy Enoch Pratt Free Library.)

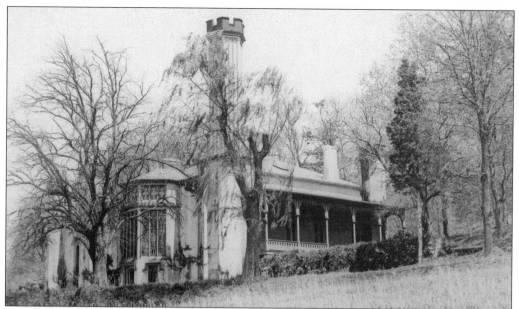

Built on the shores of Loch Raven (in its earliest incarnation) in 1834, Glen Ellen may be one of the earliest examples of an American Gothic-style mansion. Robert Gilmore's fanciful castle was inspired by a visit to Sir Walter Scott's home in Scotland. The Gilmore family played an active role in the region, particularly Robert's son Harry Gilmore. An aristocratic soldier who sympathized with the Confederate side, Gilmore participated in many campaigns. Though not the most dramatic of his actions, Gilmore's burning of the bridges on the North Central Railroad from Cockeysville to Parkton, may have spared Baltimore County serious bloodshed, as it prevented Union troops from moving in to the area. After the war, Gilmore became a respectable citizen again and was elected chief of police by Baltimore's City Council. (Courtesy Enoch Pratt Free Library.)

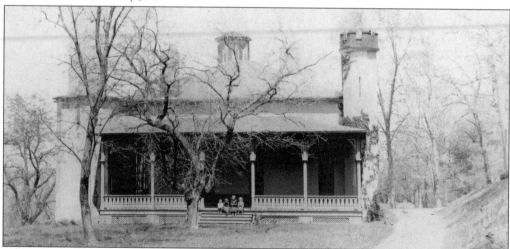

The original plans for Glen Ellen called for a moat and a drawbridge, and the house was intended to be three stories high, with a five-story crenellated tower! As anyone who has ever built a house would expect, the costs escalated and the funds ran out. The design was modified. At this angle, the house resembles a farmhouse with peculiarly large chimneys. (Courtesy Enoch Pratt Free Library.)

In 1920, Glen Ellen was purchased by Baltimore City when Loch Raven was enlarged. The house was left empty, though some of the architectural features were saved. Mr. and Mrs. Sumner Parker purchased the octagonal porch, mantelpieces, and some of the Gothic windows for their house, the Cloisters, near Brooklandville. The rest of the house fell to ruins. (Courtesy Enoch Pratt Free Library.)

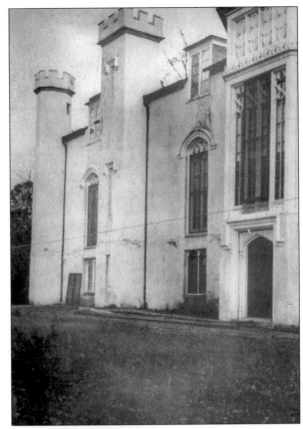

The once-beautiful home known as Timonium was named by Mrs. Archibald Buchanan. She named her house for the place in Alexandria, Egypt to which Marc Antony retreated after being deserted by his friends. The melancholy name was suggested by tragedies suffered in her own life. The town that sprang up on the estate took the name, and now, Timonium is a bustling community and the site of the Maryland State Fair. (Courtesy Enoch Pratt Free Library.)

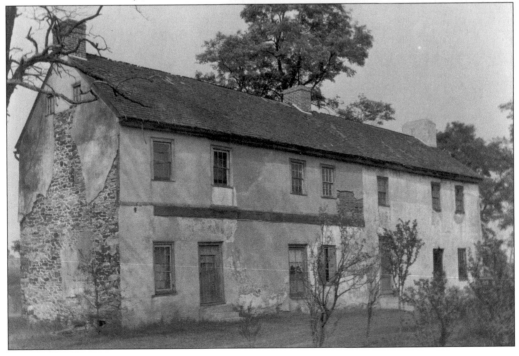

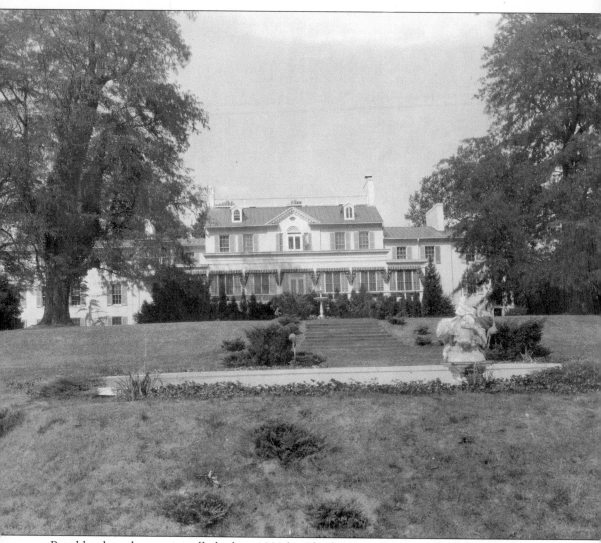

Brooklandwood was originally built *c.* 1800 by Charles Carroll of Carrollton as a wedding gift for his daughter Mary and her English husband, Richard Caton. The couple had four daughters, three of whom were known as the "Three American Graces" (what of the fourth!?). Each of these three sisters married English nobility. It is interesting to note that Mary, the oldest daughter, was first married to the brother of Betsy Patterson Bonaparte. After his death, Mary became the wife of the Marquess Wellesly, the Duke of Wellington's brother. This relationship between two Baltimore beauties connected the nineteenth century's greatest rivals, Wellington and Bonaparte, who both had sisters-in-law from Baltimore! (Courtesy Enoch Pratt Free Library.)

In 1916, Isaac Emerson, the inventor of Bromo Seltzer and a prominent Baltimore businessman, bought Brooklandwood. Aside from his business concerns, Emerson kept a herd of dairy cows on the estate. He operated a dairy in these buildings near the corner of Falls Road and Green Spring Valley Road. These buildings, pictured in the 1930s, were renovated in 1976 for the Montessori School. (Courtesy BGE and Enoch Pratt Free Library.)

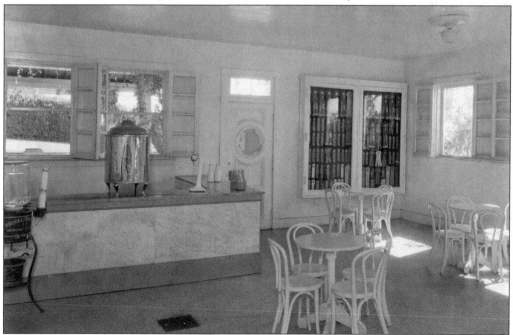

This counter at the Emerson Dairy in the 1930s hardly looks like it could compete with Ben & Jerry's, but at the height of its operation, the dairy served 600,000 people annually. After a leisurely drive in the countryside, Sunday drivers could stop at Emerson's Dairy for a fresh, cold glass of milk or an ice cream. (Courtesy BGE and Enoch Pratt Free Library.)

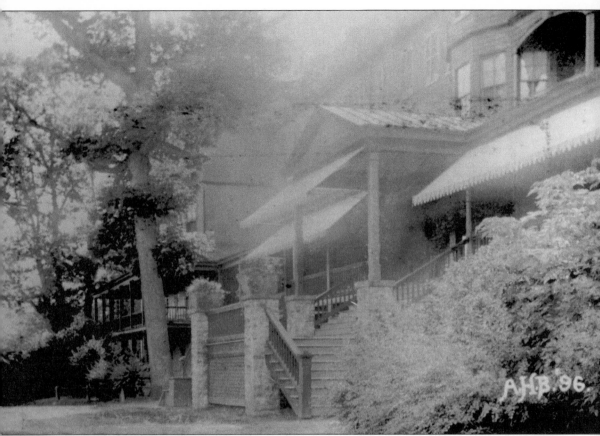

The beautiful Chattolanee Springs Hotel in Green Spring Valley was regarded as one of the most beautiful and sophisticated hotels of its day. It was built in 1890 to replace the Green Spring Hotel (located near the present-day Moales Lane), which had burned to the ground in 1860. The Chattolanee had 148 rooms and commanded a spectacular view of the surrounding countryside. Amenities included ballrooms, billiard parlors, card rooms, bowling alleys, swimming pools, tennis courts, and a dining room. Two railroads, the Green Spring Branch and the Westminster Line, connected only a short carriage ride away, making it an easy trip for affluent Baltimoreans. The Hotel finally closed in 1913, when many of the former patrons had built their own summer cottages in the area. (Courtesy Baltimore County Public Library.)

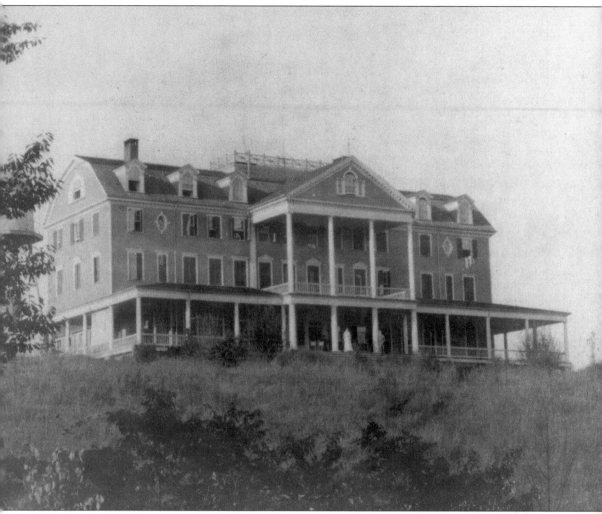

The Avalon Hotel was a luxurious inn that drew Baltimoreans out of the city for the summer. Perched on the top of a hill near Green Spring Valley Road and Park Heights Avenue, the inn commanded a spectacular view of the green fields below. Sadly, on the morning of October 30th, with a small number of guests still in residence, the Avalon was destroyed by fire. Neighbors from Burnside and the Shoemaker's Dairy helped firemen save as many belongings as possible. As with many grand hotels of its kind, the wood frame structure was a total loss. Soon thereafter, Louise Stotesbury built a magnificent mansion. The nine bedroom, six bathroom house was built in 1917 for $1 million. The house was christened "Rainbow Hill" by Louise's second husband, Major General Douglas MacArthur, in honor of the Rainbow Division, his command during the First World War. Mr. and Mrs. Henry Rosenberg purchased Rainbow Hill in 1940. Since 1964, it has been a retirement home. (Courtesy Enoch Pratt Free Library.)

This breathtaking view of the Worthington Valley illuminates why so many of Maryland's most prominent families built their homes in this scenic area. The area is largely unchanged today, though increasing numbers of houses threaten views such as this one. (Courtesy author's collection.)

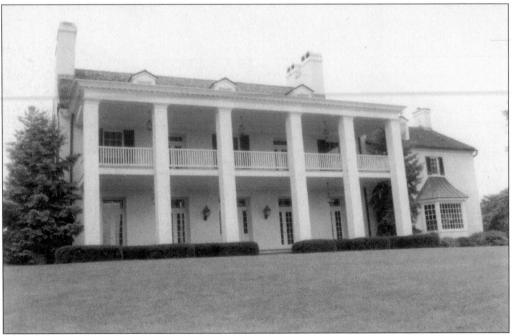

This beautiful house, with its distinctive two-story porch, is known as Montmorenci. Beautifully situated on a hill overlooking the Worthington Valley, the Worthingtons built Montmorenci in 1742. One of the notable architectural features of the house is its dramatic "hanging" stairway in the center hall. (Courtesy author's collection.)

Originally, Sagamore Farms was owned by the Worthington family as part of a larger land grant, called Welshe's Cradle. In 1885, Charles Councilman purchased the farm, including a lovely Georgian house, and named it "Bloomfield." In the 1930s, Alfred Gwynn Vanderbilt bought the farm and transformed it into one of the most modern thoroughbred breeding and training facilities of its day. (Courtesy author's collection.)

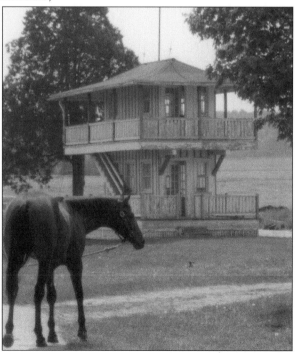

An observation tower along the track is one of the features of Sagamore's distinctive white-frame and red-roofed complex. Vast pastureland, numerous stables, paddocks, exercise tracks, and a completely enclosed exercise track were designed to provide the finest breeding and the most advanced training. Sagamore succeeded in producing two famous winners, Discovery and Native Dancer. Sagamore Farms is part of the Maryland Land Trust and continues to operate as a horse farm. (Courtesy author's collection.)

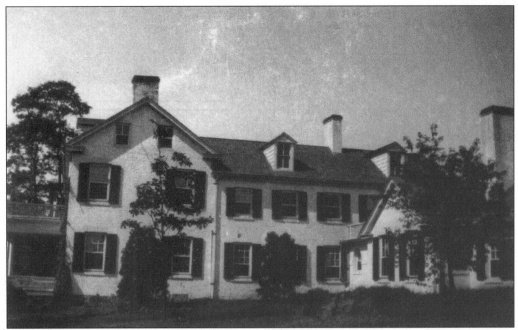

One of the original houses on the Worthington tract, Belmont Farm was built between 1780 and 1800 by a son of Samuel Worthington. The bricks were fired on the property, and in the back, the old slaves quarters were built of stone. The bricks have been whitewashed and the old quarters adjoin the house, but the original woodwork remains. (Courtesy collection of Mr. and Mrs. Charles C. Fenwick.)

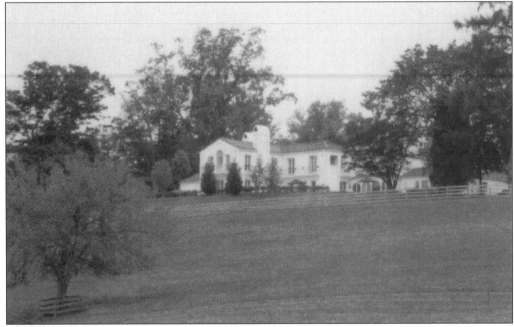

This Mediterranean-style house, built in the shape of a cross, was once the home of famed opera diva Rosa Ponselle. Perched upon a hill along Green Spring Valley Road, it commands a wonderful view of the surrounding area. (Courtesy author's collection.)

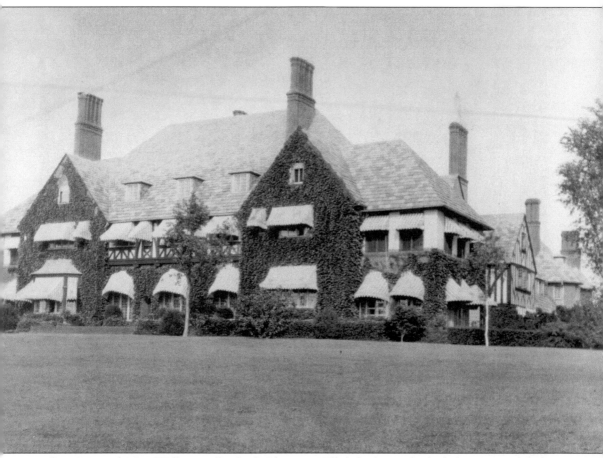

When Mr. and Mrs. Wilbur Miller built Pleasant Hill (which overlooked the Western Run Valley) between 1911 and 1916, the area was so rural that the roads were still unpaved and there was no electricity north of Brooklandwood (the Emerson estate). Brick, tile, and paneling, which had been imported from Europe, had to be hauled by mule wagons from Cockeysville. The result of this monumental effort was this magnificent Tudor house, commonly referred to as the "Mansion." In 1932, Pleasant Hill was sold to a chemical company as a research facility, but instead the house was rented to the Children's Rehabilitation School, which was a school for children with cerebral palsy. In 1953, the Mansion was sold at auction for $250,000 to the Loyola Institute. Rather than using it as a retreat center, as originally intended, the Mansion was allowed to remain empty. Sadly, Pleasant Hill became a target for vandals and was eventually razed by the county. All that remains of this great house are the two brick gatehouses, which are now private homes. (Courtesy collection of Mr. and Mrs. Charles Fenwick.)

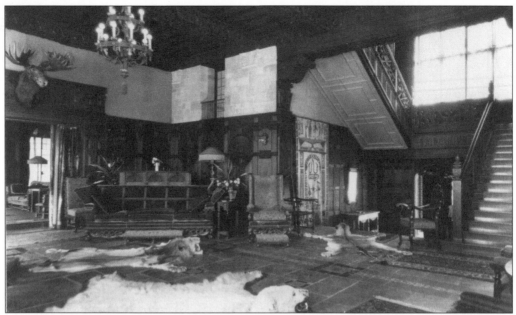

The great hall, with bear and lion skin rugs scattered across the stone and tile floor, was the scene of many wonderful parties. In addition to being active socially, the Millers were interested in preserving and enhancing their community. Mrs. Miller was instrumental in the preservation of St. John's in the Valley, renovating the sanctuary and the rectory in 1927. Mr. Miller rebuilt the buildings on Shawan corner. John G. Brown's Store and the small, but charming, brick houses across the road are the result of his efforts. (Courtesy collection of Mr. and Mrs. Charles C. Fenwick.)

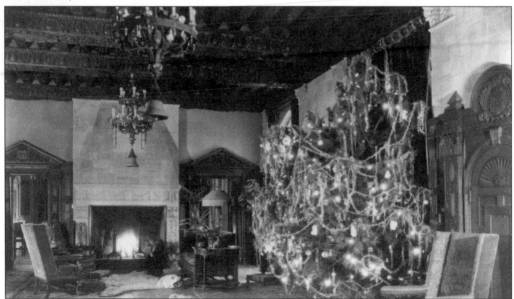

The Millers gave debutante parties during the Christmas season. A portable dance floor was put down and guests could dance to live music in a medieval atmosphere! In addition to the debutante parties, the Millers gave an annual Christmas party for the large household and farm staff, along with their families. (Courtesy collection of Mr. and Mrs. Charles C. Fenwick.)

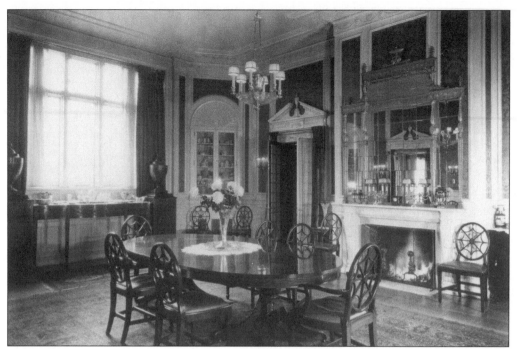

Silk damask hung from the walls and the ceiling is decorated with elaborate plasterwork. This formal dining room was one of 50 rooms at Pleasant Hill. Twenty bathrooms (one for every bedroom) and an elevator were amenities very few houses could boast at this time. (Courtesy collection of Mr. and Mrs. Charles C. Fenwick.)

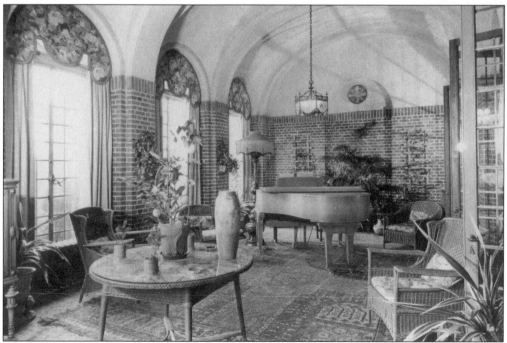

This room was, at one time, an aviary. The large cage of exotic birds was replaced, however, with a piano for the Miller children. (Courtesy collection of Mr. and Mrs. Charles Fenwick.)

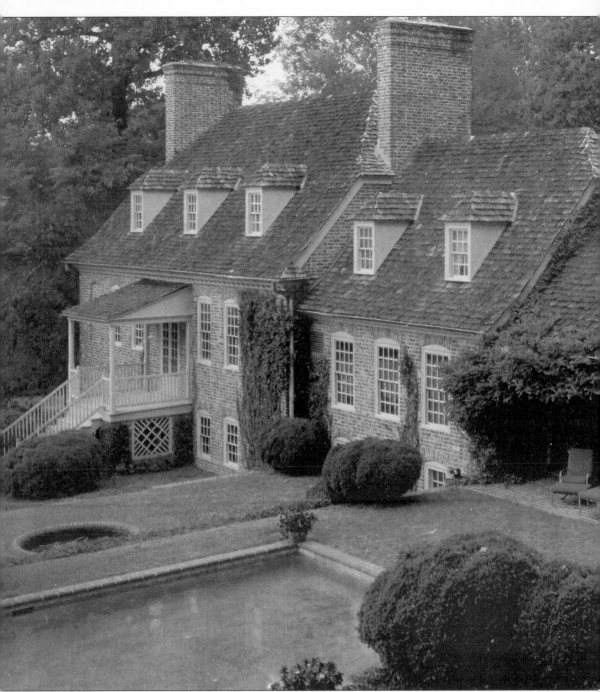

Box Hill is a gracious home on Western Run Road that has a fascinating and unusual provenance. This historic house was built *c.* 1749 in Bladensburg, Maryland, by Dr. David Ross, who was a surgeon in the Continental Army. The house itself also saw service, as it was used as a hospital during the War of 1812. Interestingly, both Americans and British soldiers were treated here. Threatened with destruction in 1957, the house was delicately dismantled and stored. In 1963, it was painstakingly reassembled at its current location. (Courtesy Cindy and John Heller.)

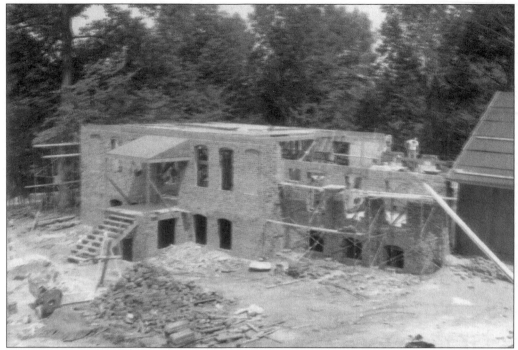

This photo shows the reconstruction of Box Hill at its present site. Over 22,000 bricks and brickbats, paneling, flooring, trim, windows, and dormers—even the original handmade nails—were expertly reassembled. An authority from Preservation Maryland was instrumental in ensuring the project's success. (Courtesy Cindy and John Heller.)

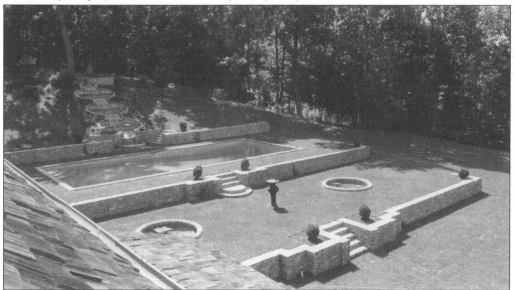

Box Hill, named for its profusion of enormous boxwood, was landscaped with plants and flowers compatible with eighteenth-century Maryland. The grounds feature a terraced garden, cascading waterfall, two lily ponds, and a pool. There is also a guest house, which was built in Kent County, Maryland, around 1730. As with the main house, it is a marvelous example of creatively preserving our architectural heritage. (Courtesy Cindy and John Heller.)

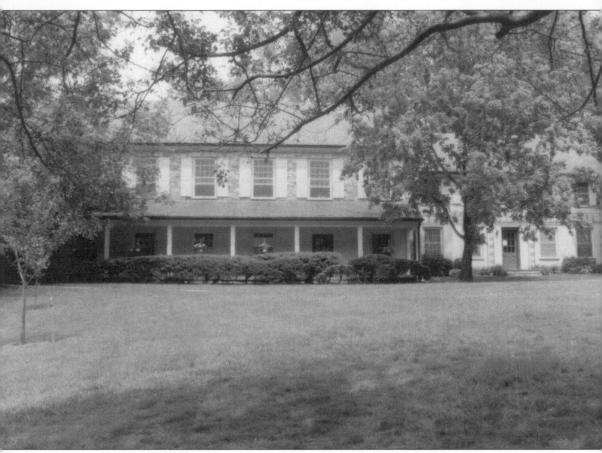

This pretty stone building was once the dining hall for the Oldfield's School. Founded in 1867 by Mrs. John Spears, the school first held classes in the white frame house, called The Old House, that now serves as administrative offices. The girls' school, located on Glencoe Road in Sparks, has educated a few young women destined for royalty. Alumnae include the Duchess of Windsor, (who was Wallace Warfield at the time), and a daughter of Queen Noor and the late King Hussein of Jordan. (Courtesy author's collection.)

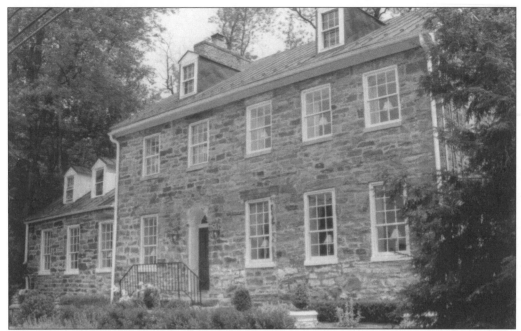

The Milton Inn, located on York Road, Sparks, has a colorful history. During the first half of the nineteenth century, the inn was a watering hole for travelers on the busy York Turnpike. The inn also served the drivers and horses that brought Quakers to one of the meeting houses that dotted the northern valleys. Presumably, the carriage drivers would kill time at the inn until they had to return to the Friend's Meeting House on Priceville or Cuba Road to meet their more reverent passengers. In the 1850s, the inn became the Milton Academy, a military school for young men. The school thrived until the early 1900s, when the building became a private home. The building has since returned to its original purpose, albeit more refined, serving the area as a popular place to spend a romantic evening. (Courtesy author's collection.)

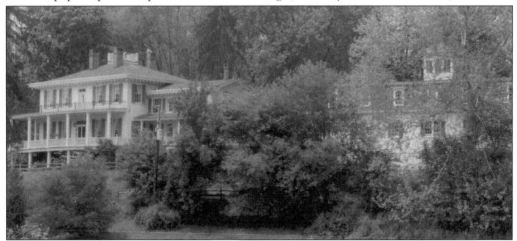

The Glencoe Hotel was built by Peter Mowell between 1851 and 1856. The hotel was located near the Glencoe depot on the North Central Railroad line and provided a summer respite from the city. The ornate wrought-iron work on the porch rail is indicative of the fact that Mr. Mowell's was an iron-founder. The house still stands and serves as a private home. (Courtesy author's collection.)

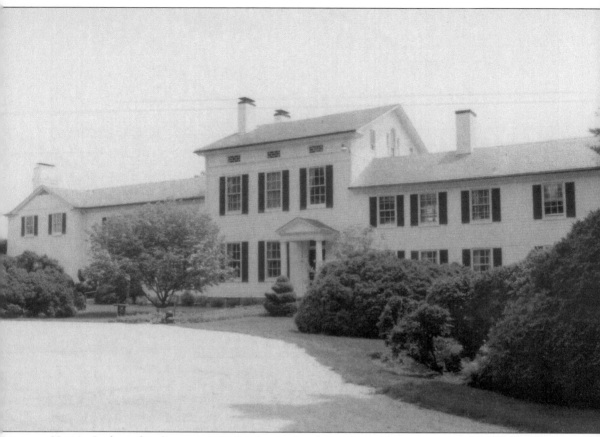

Harvey Ladew's first home in Maryland was a bungalow he built on the grounds of the Elkridge Harford Hunt Club on Pocock Road. In 1929, Ladew bought the Scarff Farm, a 200-acre property (very close to the hunt club) on Jarrettsville Pike. Ladew immediately set to work on the simple farmhouse, creating one of the loveliest country homes in America. The wing on the left side of the house accommodates the Oval Library, which was included on a list of "The 100 Most Beautiful Rooms in America." Ladew appropriately named his property Pleasant Valley Farm. Today, tours of the house allow people to enjoy the impeccable, as well as the whimsical taste, which characterizes Pleasant Valley Farm. (Courtesy Ladew Topiary Gardens.)

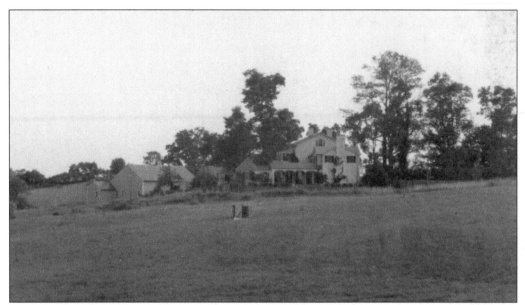

A diamond in the rough, this pasture, c. 1929, will soon be transformed into the lawn known as "The Great Bowl." Mr. Ladew's fondness for long vistas, combined with his appreciation for structure, gave him the ability to "tame" the meadows around his farm while maintaining the open feel of the countryside. (Courtesy Ladew Topiary Gardens.)

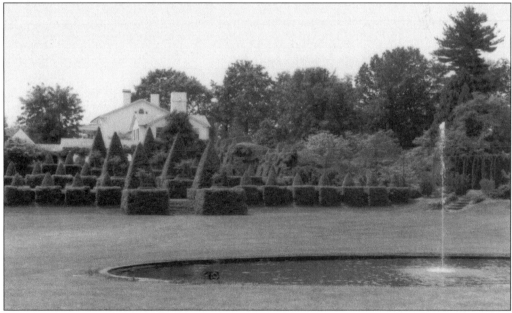

What a difference a little gardening expertise can make! The Great Bowl is the center of the crossed axis design, which governs Harvey Ladew's gardens. At the center, an oval swimming pool graces the green lawn. On summer evenings, picnickers scatter across the grass and enjoy the music provided by Ladew's summer concert series. We imagine Harvey Ladew would be pleased that his tradition of hospitality lives on. The gardens are open to the public throughout the warm months, and it is well worth the lovely drive to spend an afternoon strolling about this unique gem in the heart of "My Lady's Manor." (Courtesy Ladew Topiary Gardens.)

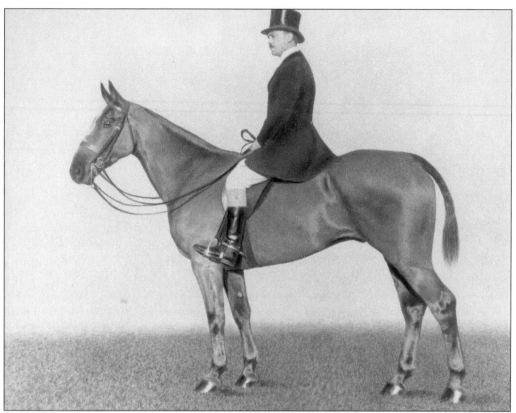

Harvey S. Ladew, though a New Yorker by birth, followed his love for fox hunting to Maryland in 1927. He purchased a farm adjacent to the Elkridge-Harford Hunt Club in the part of Baltimore County known as My Lady's Manor. Shortly after joining the Hunt Club, Mr. Ladew became the master of fox hounds. An active and enthusiastic member, he also hosted the Harford Hunt Races in November of 1932, and again several times after that. Mr. Ladew must have loved the convenience of watching the races from his front terrace. Here, Mr. Ladew sits astride Carry-On, one of his many hunters. (Courtesy Ladew Topiary Gardens.)

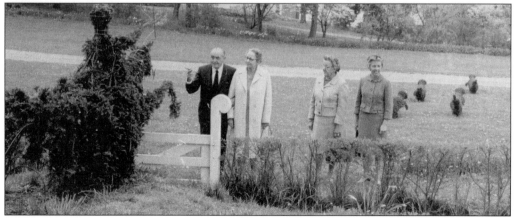

Harvey S. Ladew frequently entertained garden clubs from around the country. Here, he shows a group of ladies the "Huntsman and Hounds." The framework, which supports the topiary, can be seen in the head where the foliage has yet to fill in. (Courtesy Ladew Topiary Gardens.)

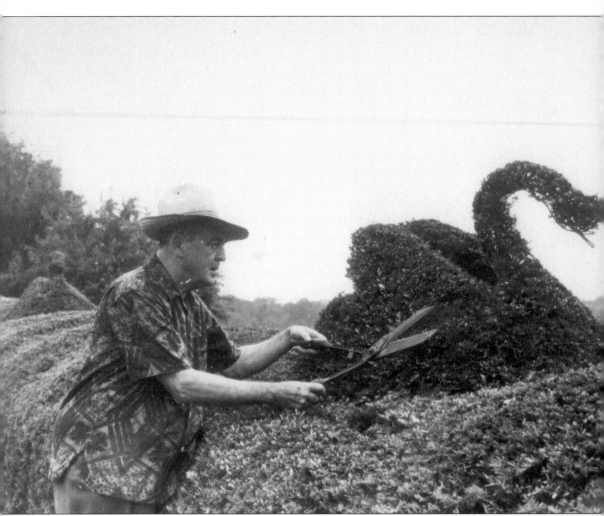

While spending the hunting season in England, Harvey Ladew had the opportunity to see several fine examples of the gardening art known as topiary. By training evergreens, such as yew and hemlock, on specially created frames, various forms can add structure and, in the case of Ladew's garden, amusement. Mr. Ladew accomplished the creation of a remarkable and renowned garden without the aid of a professional landscape designer. He taught his gardeners to create topiaries but did a great deal of the work himself. Here, Mr. Ladew works on one of the swans that grace the crest of the hedges around the Great Bowl. (Courtesy Ladew Topiary Gardens.)

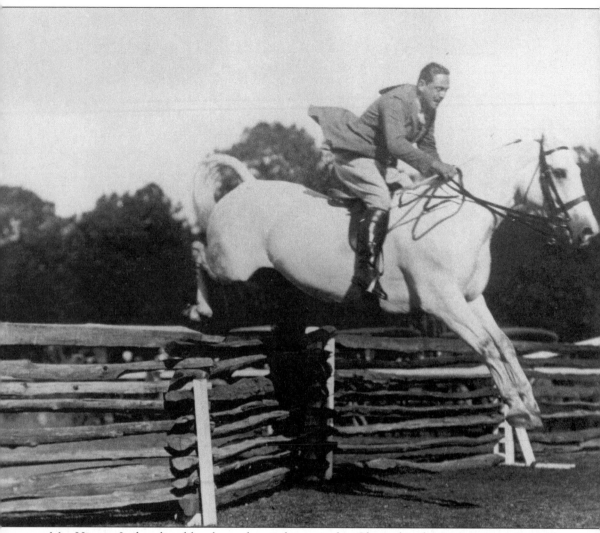

Mr. Harvey Ladew handily clears the timbers on the Ghost, his favorite mount. A vivid example of Mr. Ladew's strict code of behavior for a gentleman was demonstrated when he facetiously offered to sell the Ghost for the outrageous price of $10,000. When the amount was agreed to, Mr. Ladew felt he had no choice but to honor his word, as painful as it was to part with his favorite hunter. (Courtesy Ladew Topiary Gardens.)

Two

CLUBS AND DIAMONDS

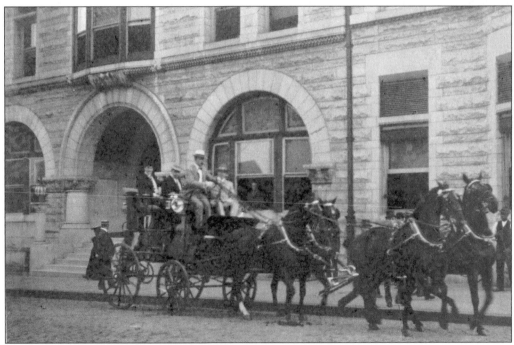

A magnificent four-in-hand departs from the Maryland Club at its current location on Eager Street. Founded in 1857, invitations to join—or even just to dine—have always been highly prized. The club's first president was Jerome Napoleon Bonaparte, the son of the ill-fated union between Betsy Patterson and Jerome Bonaparte, the younger brother of the famed emperor. The club's roster has always been comprised of accomplished and illustrious gentlemen—and a few scallywags. Over the years, members have included such disparate personalities as Douglas MacArthur, Ogden Nash, and H.L. Mencken, along with the usual complement of movers and shakers. (Courtesy Maryland Club.)

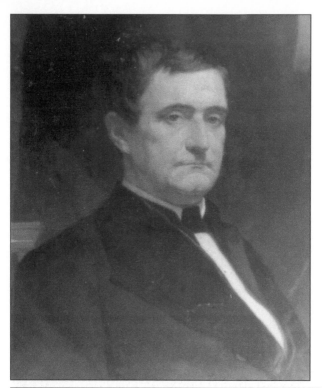

Jerome Napoleon Bonaparte was the first president of the Maryland Club. The only offspring of the star-crossed romance of Betsy Patterson and Jerome Bonaparte, he attended Harvard, married an American, and settled comfortably here. Although his parents' marriage was never recognized by his father's family, he was, nonetheless, awarded French citizenship. While his mother's life ended on a bitter note lamenting lost looks, love, and loot, Jerome lived an affluent life, surrounded by good friends and fast horses. (Courtesy Maryland Club.)

· MENU ·

COCKTAILS

MARTINIS MANHATTANS

☆ ☆ ☆

CELERY OLIVES

HOT ROAST TURKEY PIG TAILS

CRANBERRY SAUCE

CREAMED HOMINY SAUERKRAUT

COLD

ROAST SUCKLING PIG

SLICED SMITHFIELD HAM

ROLLS AND BUTTER

HOT MINCE OR PUMPKIN PIE

DEMI TASSE

WINE LIST

SPECIAL

ACKERMAN DRY ROYAL............ bottle $4.00

A good NATURAL SPARKLING FRENCH WINE, *priced to reduce our stock and to conserve our* CHAMPAGNE. *We recommend its purchase*

☆ ☆ ☆

PERRIER JOUET	1928	$7.00
SARCEY FRERES	1928	$5.50
KORBEL BRUT, CALIFORNIA	1933	$5.00
GREAT WESTERN, NEW YORK		$3.75

This Maryland Club menu from New Year's Day, 1944, shows a variety of Maryland staples, such as creamed hominy and sauerkraut. Because it was wartime, the menu encourages members to drink sparkling wine to conserve the champagne supply. (Courtesy Maryland Club.)

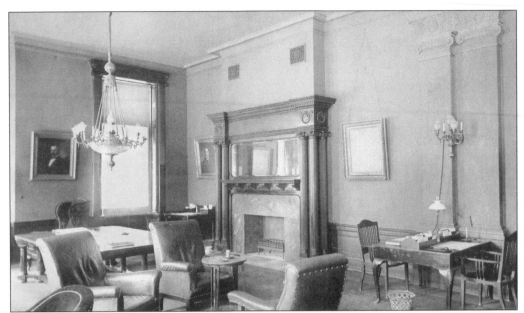

The Maryland Club moved to its current location at the corner of Charles and Eager Streets at the very end of 1891. This is a view of the smoking room, c. 1895. As with other men's clubs of the day, it boasted rooms for a variety of entertainments and services, such as a billiards room, card room, library, bar, dining room, bedrooms, and barbershop. (Courtesy Maryland Club.)

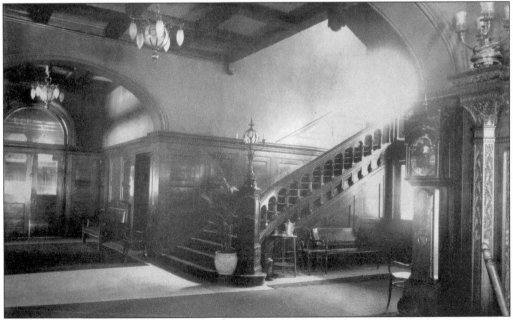

The Maryland Club has a long and cherished tradition of hospitality. This photo shows the grand staircase as it looked c.1895. The adjoining entry hall, replete with an enormous fireplace, has been the setting for many entertainments. A lapse in the club's hospitality occurred during the Civil War. Known as a hotbed of Southern sympathizers, at one point Union guns were trained on it, to ensure the members' good behavior. (Courtesy Maryland Club.)

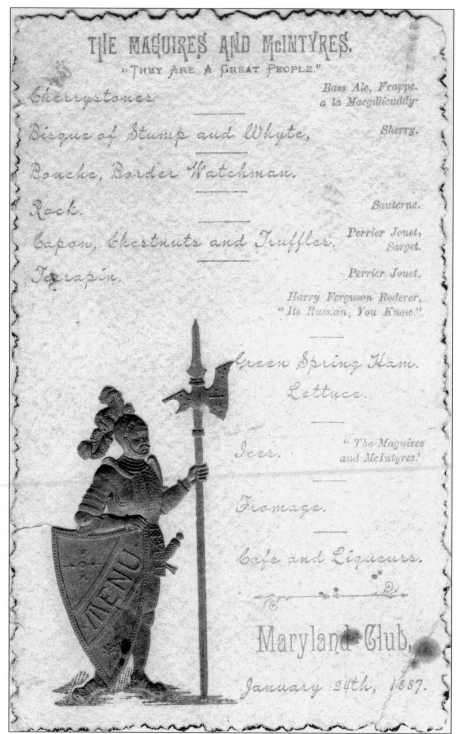

THE MAGUIRES AND McINTYRES.

"THEY ARE A GREAT PEOPLE."

Cherrystones

Bisque of Stump and Whyte.

Bouche, Border Watchman.

Rock.

Capon, Chestnuts and Truffles.

Terrapin.

Bass Ale, Frappe.
a la Macgillicuddy.

Sherry.

Sauterne.

Perrier Jouet,
Sarget.

Perrier Jouet.

Harry Ferguson Roderer,
"Its Russian, You Know."

Green Spring Ham.

Lettuce.

Ices. "The Maguires
and McIntyres."

Fromage.

Cafe and Liqueurs.

Maryland Club,

January 24th, 1887.

This delightful menu is for a party held on January 24, 1887, at the Maryland Club and entitled, "The Maguires and McIntyres - They are a Great People." The food served appears great, as well, both in quality and quantity. (Courtesy Maryland Club.)

78

Before the Civil War, Baltimore had served as the financial center of the South. When war broke out, the federal government enacted restrictions that hurt Baltimore's financial institutions. Once known as the "Boston of the South," Baltimore had to make a long recovery back to become a financial center. John Marshall founded the Provident Savings Bank in 1886. This building was located at Howard and Saratoga Streets. (Courtesy Enoch Pratt Free Library.)

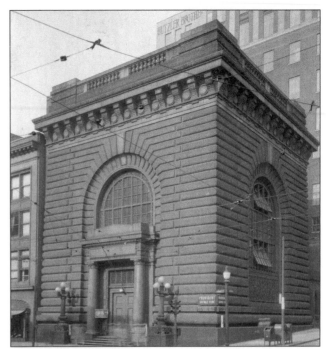

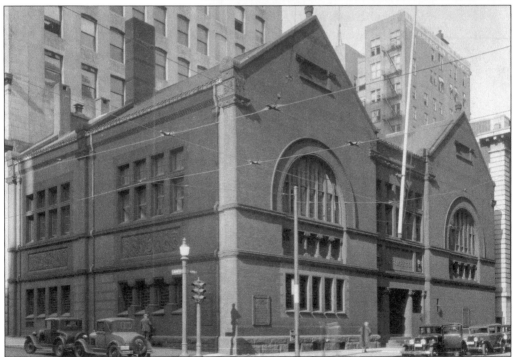

The Mercantile-Safe Deposit & Trust Company, one of the oldest financial institution in Baltimore, was founded by a large group of Baltimore businessmen and entrepreneurs. Among them were Aruna S. Abell, Johns Hopkins, Enoch Pratt, Benjamin Shoemaker, Jay Alexander Shriver, and William T. Walters. This building stood at the northeast corner of Calvert Street and Redwood Street. (Courtesy Enoch Pratt Free Library.)

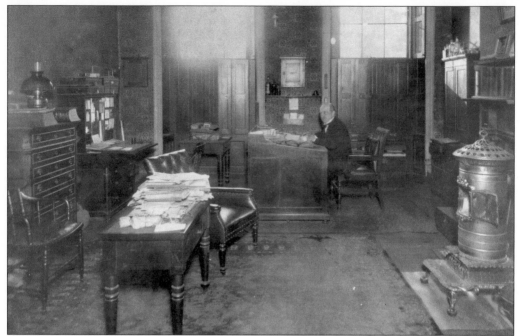

Elias Glenn Perine's office at 18 East Lexington Street, *c.* 1905, illustrates the enormous gulf between our modern workplace and that of a century ago. The coal burning stove provided heat, which was an amenity most working Americans did not enjoy. While keeping copious handwritten records may seem outdated to today's office worker, the cluttered desk on the left indicates that some things never change. (Courtesy collection of Mr. and Mrs. Allan Mead.)

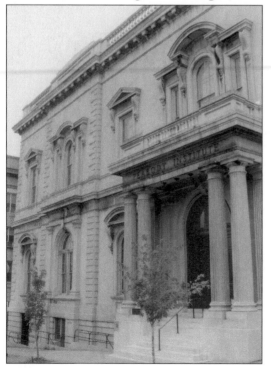

To walk about East Mount Vernon Place and hear the strains of music drifting out of the Peabody Institute has to be one of the unique pleasures in Baltimore. A native of Massachusetts, George Peabody (1795–1869) came to Baltimore when he was 20. He ran a successful clothing business for the next two decades, before going to London, where his continued success made him very wealthy. As a show of gratitude, Peabody gave over $1 million to open a music conservatory. The Peabody Institute was completed in 1861. For almost 150 years, the conservatory has been regarded as one of the finest institutions of its kind. The famous Beaux Arts Library has been the setting for many weddings and galas, but the musicians who receive the excellent training and experience are the real legacy Peabody left to us all. (Courtesy author's collection.)

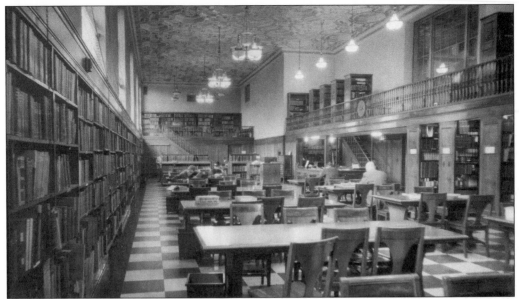

The Enoch Pratt Free Library was just one of the many legacies Enoch Pratt left to a fortunate Baltimore. In 1882, he gave over $1 million to provide Baltimoreans with free access to books. A tradition of public service and charitable giving has made Baltimore's social and cultural institutions some of the finest in the world. Andrew Carnegie (another of America's great philanthropists) claimed Enoch Pratt as inspiration for his own charitable giving. Pictured here is one of the many departments in the Central Branch, located on Cathedral Street. (Courtesy Enoch Pratt Free Library.)

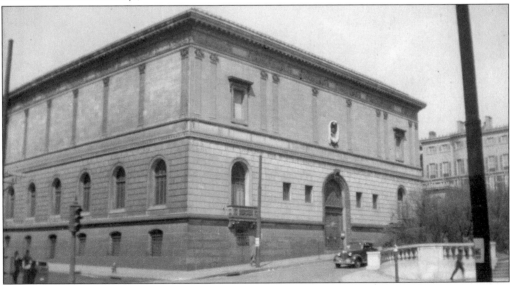

The Walters Art Gallery, which overlooks Mount Vernon South, was built by Henry T. Walters to house the treasures he and his father, William T. Walters, had accumulated in 80 years of travel and collecting. The Italian Renaissance–style building opened to the public in 1909. It provides Baltimoreans the opportunity to appreciate what is widely regarded as the world's best collections of fine art and archeological treasures. (Courtesy Enoch Pratt Free Library.)

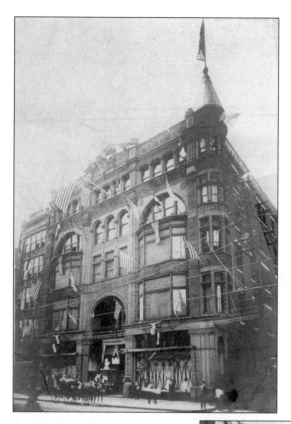

Howard Street was Baltimore's shopping district. Gutman's, Hutzler's, the May Company, and Stewart's all provided the same caliber of goods and services that New York and Philadelphia shoppers expected. Pictured here is the old Hutzler's, as it looked in June 1903. (Courtesy Enoch Pratt Free Library.)

Here is a view down Howard Street. In those days, ladies wore white gloves and hats, rode the street car to Howard Street, and made a day of shopping for clothes or household goods. Over time, as the middle class began to move out to the suburbs, the stores abandoned Howard Street and followed their clientele to new, though less grand, buildings outside the city. The old buildings still stand, and the city is trying to breathe new life into them through renovations and adaptive reuse. (Courtesy Enoch Pratt Free Library.)

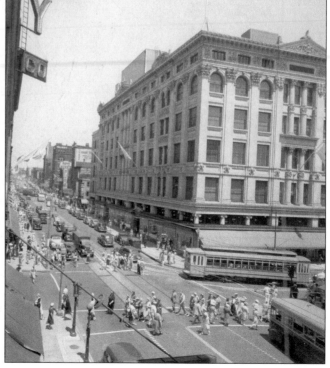

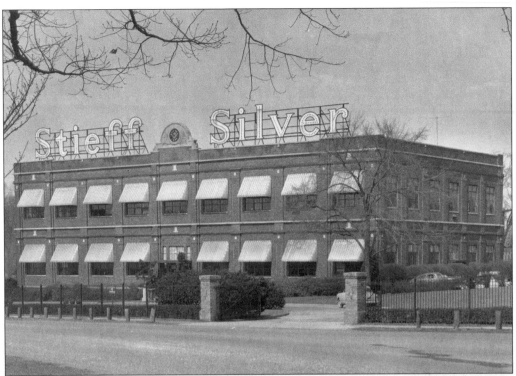

Originally located on Cider Alley, Charles C. Stieff founded the Sterling Silver Manufacturing Company in 1892. The name was later changed to the Stieff Silver Company. The groundbreaking for the modern factory, located on Twenty-eighth Street, was held in 1924. A second story was added later. The world-renowned company produced the finest sterling, silver plate, pewter, hollowware, and flatware items. (Courtesy Charles C. Stieff II.)

For generations, lovely silver from the Stieff and Kirk companies have graced the tables and sideboards of not only Baltimoreans, but a wider range of the affluent with a good eye for fine craftsmanship. Often among a family's most valuable and treasured possessions, such pieces are a tangible reminder of a more gracious lifestyle, all too often overlooked in today's fast food world. (Courtesy Charles C. Stieff II.)

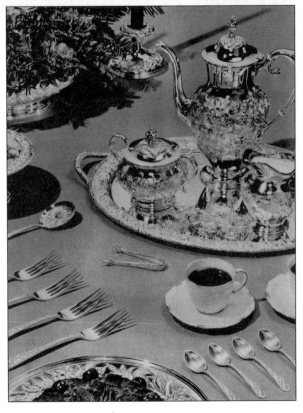

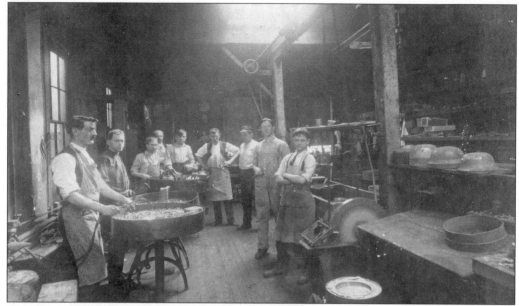

This fascinating photo shows the old silversmith department. The steel drums were filled with stones to absorb the heat as the silversmith worked with a blowtorch-like instrument for soldering. For example, the silversmith in front could be attaching a handle to a teapot. (Courtesy Charles C. Stieff II.)

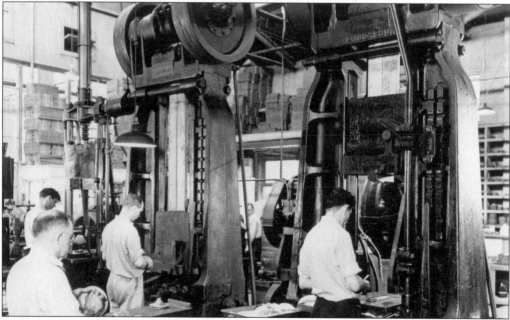

It is difficult to believe that such beautiful creations are produced by such massive machines. This photo shows a drop hammer, which would form pieces. Over the years, the Stieff Silver Company has been involved in a variety of unusual and prestigious projects, in addition to their daily business. For example, during the celebrations for our country's bicentennial in 1976, they were commissioned to make 500 silver keys, duplicating the original key to Independence Hall in Philadelphia. (Courtesy Charles C. Stieff II.)

These are five spectacular examples of the famous repousse rose pattern for which the Kirk Silver Company was famous. In 1979, the company was purchased by Stieff, and was known thereafter as the Kirk-Stieff Company. Repousse, which means "beaten out," was a form of intricate handmade ornamentation. Sadly, it was discontinued as skilled craftsmen could no longer be found. (Courtesy Charles C. Stieff II.)

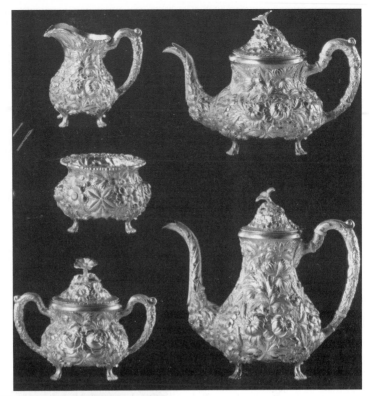

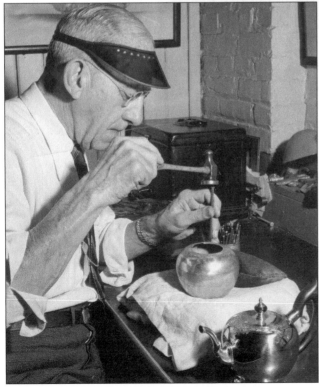

An artisan is flat chasing a Williamsburg teapot—perhaps it will become part of a lucky bride's new tea service. Flat chasing employs a different technique than that found in the more complicated repousse. The Stieff Silver Company, working in conjunction with Colonial Williamsburg, produced two highly popular flatware patterns: the Williamsburg Shell and the Queen Anne. In addition, they produced hollowware, bowls, and other items that had been copied after old collection pieces. (Courtesy Charles C. Stieff II.)

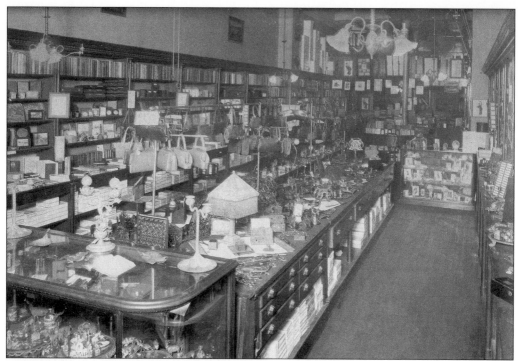

Lycett, Inc. opened a store on Charles Street in 1835. Well stocked in the decorative items that give a house personality, the store became an integral part of Baltimore's downtown shopping district on Charles Street. (Courtesy Isaac Lycett.)

Baltimore brides-to-be would make sure to visit Lycett's first floor to register for their fine china, crystal, and sterling hollowware. Baltimore was fortunate to have three excellent silver companies, Stieff, Kirk, and Schofield; Lycett's carried all three, as well as 77 patterns of china dinnerware. (Courtesy Isaac Lycett.)

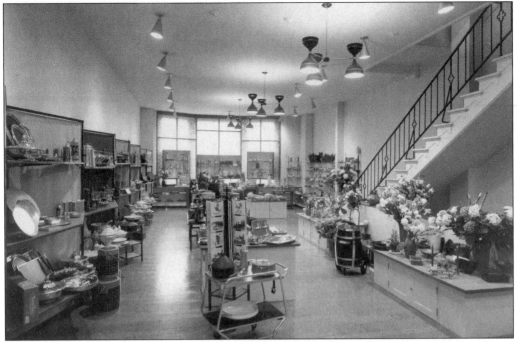

In 1957, Lycett's remodeled the store at 317 North Charles Street. The second floor, pictured here, was filled with gift items still found in Baltimore homes today. Lamps with wild duck motifs, attractive serving ware, and myriad other household items could be purchased as gifts or for oneself. (Courtesy Isaac Lycett.)

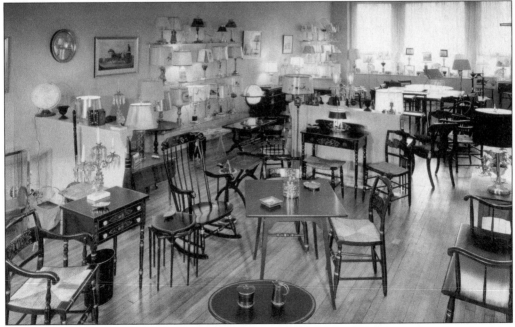

Fine cherry reproduction furniture, framed prints, and decorative lamps were found on the third floor. The Hitchcock furniture, seen in the foreground, was a particularly popular choice. (Courtesy Isaac Lycett.)

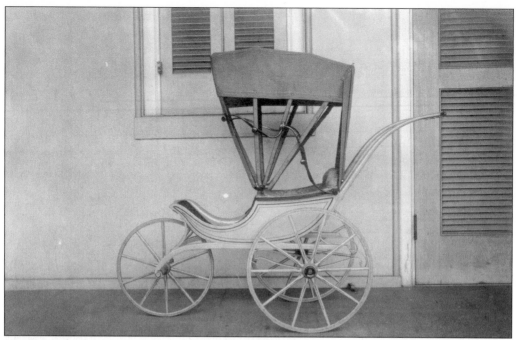

In 1866, a child's first introduction to the world could have been from a jaunty carriage like this one. While this model would not conveniently fold up for easy storage, it certainly had style! (Courtesy collection of Mr. and Mrs. Allan Mead.)

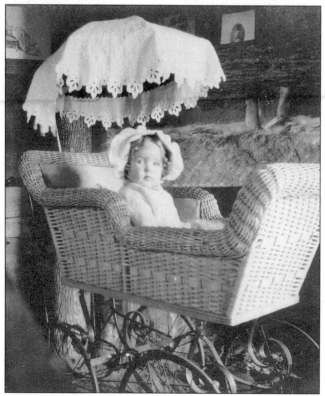

This turn-of-the-century wicker-model pram is equipped with a parasol and decked out in lace. Its little passenger looks as if she is expecting a turn in the park. (Courtesy Mr. and Mrs. Hal C. Whitaker.)

The charm and innocence of a bygone era are captured in this summertime family portrait from the 1920s. (Courtesy Mrs. René J. Gunning Sr.)

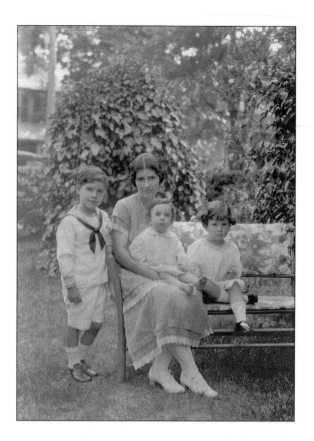

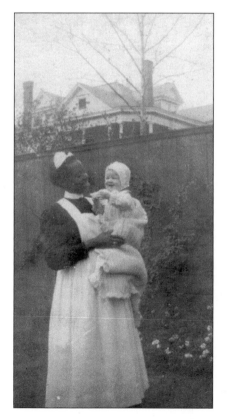

Household staff was invaluable to affluent families in the first half of the 1900s. It was not uncommon for several generations in a family to be brought up by a dearly loved nursemaid, who then, in turn, was cared for by those whose noses and tears she had once wiped. (Courtesy Mr. and Mrs. Hal C. Whitaker.)

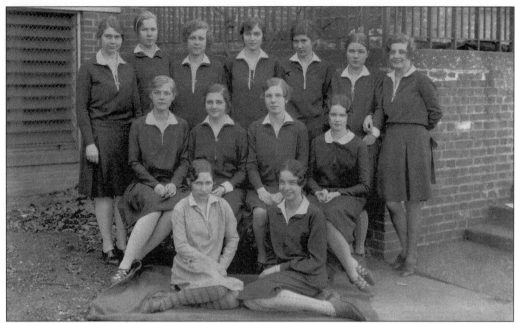

The Roland Park School for Boys and Girls was created by the Roland Park Company to attract city folks who were considering a move out to the new neighborhood. In 1894, Katherine and Adelaide Howard held classes for boys and girls in a home in Roland Park. In 1901, the school was incorporated and became the Roland Park Country School. In 1916, the school moved to a new campus on University Parkway. This new school was one of the revolutionary "open air" schools. With the belief that fresh air (even in January!) would prevent the spread of polio and other serious illness, students attended class with the enormous waist-to-ceiling-high windows open. Wrapped in blankets, it must have been a challenge to concentrate. These young ladies, at a more temperate time of year, were photographed on the front steps in 1928. (Courtesy collection of Hildegarde Denmead LeViness.)

The Girl's Latin School was originally founded by the Women's College of Baltimore (later known as Goucher College). In 1914, the school was relocated to the Wynans mansion at 1217 St. Paul's Street, where this photograph was taken. As the name suggests, the curriculum put a strong emphasis on the study of Latin. In 1927, Girl's Latin moved up to 10 Club Road in Roland Park. The school finally closed it doors in 1951, because the endowment had been exhausted. (Courtesy Enoch Pratt Free Library.)

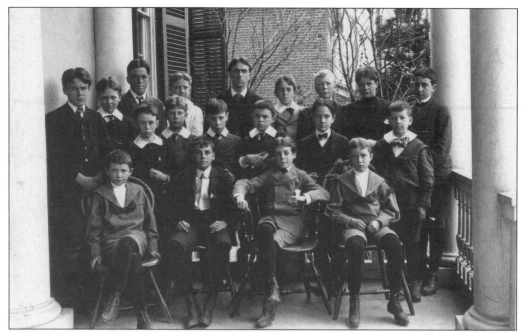

The Country School for Boys, now known as the Gilman School, is an all boys school that was located at Homewood from 1897 to 1910. This class photo of students and their teacher was taken on the porch. The cool assurance of the young boy seated front and center indicates he might be practicing to be a future captain of industry. (Courtesy Homewood House Museum, The Johns Hopkins University.)

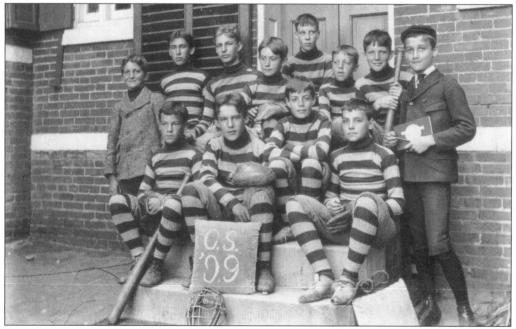

The Country School for Boys baseball team of 1899 takes a break from the playing field to pose. These striped leggings and shirts were similar to those worn by the college teams at Hopkins. (Courtesy Homewood House Museum, The Johns Hopkins University.)

Preservation Maryland (Society for the Preservation of Maryland Antiquities) is Maryland's oldest organization for historic preservation. Founded in 1931, it has had a distinguished history as an historic site manager of such treasures as Hampton, Wye Mill, and Sotterly. It also provides ongoing leadership in the areas of funding, outreach, and advocacy. Preservation Maryland is headquartered at 24 West Saratoga Street, formerly the rectory of Old St. Paul's Parish. Built in 1791, this historic building has been expertly restored. (Courtesy Preservation Maryland.)

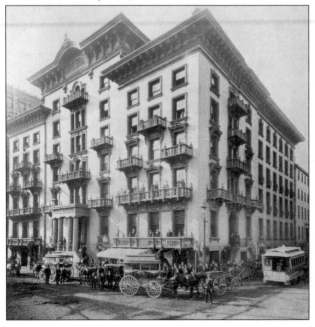

Barnum's Hotel was built in 1825 by David Barnum. The Barnum Hotel contributed to Baltimore's reputation for hospitality. One of Baltimore's most elegant hotels, the Barnum was the lodging of choice for Presidents John Quincy Adams and Andrew Jackson. Charles Dickens was a guest there and remarked that the Barnum was "the most comfortable of all the hotels in the United States." (Courtesy Enoch Pratt Free Library.)

The Belvedere Hotel, located on Chase Street, is named for John Eager Howard's estate. The hotel was built around 1902, very close to the site of Howard's home. (Courtesy author's collection.)

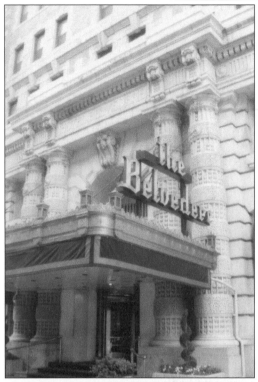

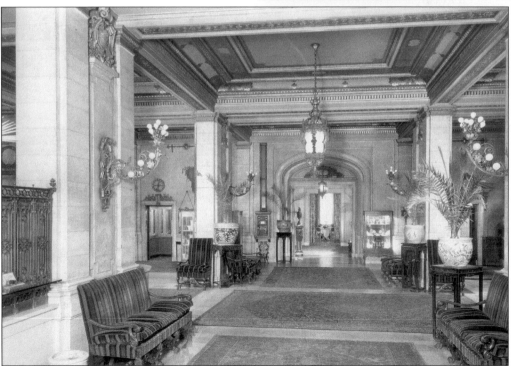

Presidents, politicians, and stars of film and stage have all passed through the sumptuous lobby of Baltimore's oldest continuing hotel. (Courtesy Enoch Pratt Free Library.)

The following Committee

Mrs. William G. Baker, Jr.	Mrs. John Gill, Jr.	Mrs. Christopher A. Russell
Miss A. W. Ball	Miss Margaret McKim Gordon	Mrs. Samuel K. Sanford
Mrs. George B. Beale	Mrs. Harry P. Hall	Mrs. Tunstall Smith
Mrs. William J. A. Bliss	Mrs. John D. Howard	Miss Kate Steele
Mrs. William Buckler	Mrs. Julian S. Jones	Miss Rosa Steele
Mrs. Bruce Cotten	Mrs. Theodore K. Miller	Miss Helen Stirling
Mrs. William DeFord	Mrs. Arthur W. Norton	Mrs. T. Nelson Strother
Mrs. James Teackle Dennis	Mrs. Richard H. Pleasants	Mrs. Donnell Swann
Mrs. William E. Ellicott	Mrs. S. Johnston Poe	Miss Annie Turnbull
Mrs. George W. Ewing	Mrs. James H. Preston	Mrs. N. Winslow Williams
Mrs. Robert Garrett	Mrs. Daniel R. Randall	Mrs. George Huntington Williams
Mrs. Edward Guest Gibson	Mrs. Charles E. Rieman	Mrs. Charles S. Winder

Mrs. Francis King Carey Mrs. Francis M. Jencks

invite _Mrs. Denmead_

to become a Charter Member of

The Mount Vernon Club

of Baltimore, Maryland

at 103 West Monument Street

Kindly reply before March 15th

to Miss Kate Steele, Treasurer, 11 East Chase Street

Mrs. Charles Rieman, Corresponding Secretary

Annual Dues $35.00, plus war tax $3.50
payable semi-annually in advance
March 15th, 1929

Make checks payable to
The Mount Vernon Club

Check must accompany acceptance

Here is a much-coveted invitation to become a charter member of the prestigious Mt. Vernon Club. Located at 103 West Monument Street in an elegant old home, the club was founded in early 1929 as a cultural and social venue for ladies. Note that a war tax was still being levied! (Courtesy collection of Hildegarde Denmead LeViness.)

Another amenity for residents of Roland Park was the Baltimore Country Club. Designed by Wyatt & Nolting, the new club was founded in 1898. In 1930, this shingle clubhouse burned to the ground. It was replaced by the elegant brick clubhouse that stands today. From its inception, the club has remained a center of social and family activity and the location of many happy memories. (Courtesy Baltimore Country Club.)

Baltimore's first 18-hole golf course was built on 150 acres that had been reserved by the Roland Park Company's planners. An anchor, as well as a drawing card for the new community, it offered a variety of sports, meals, and social activities. National tournaments, such as the Davis Cup, have been played here. In later years, the golf course was moved to a second site, known as "Five Farms." (Courtesy Baltimore Country Club.)

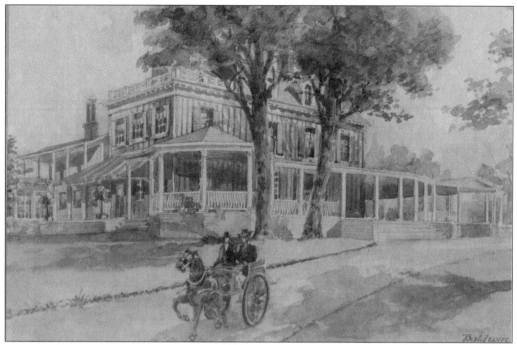

An artist's rendering of the Elkridge Club shows the proposed south addition. (Courtesy Elkridge Club.)

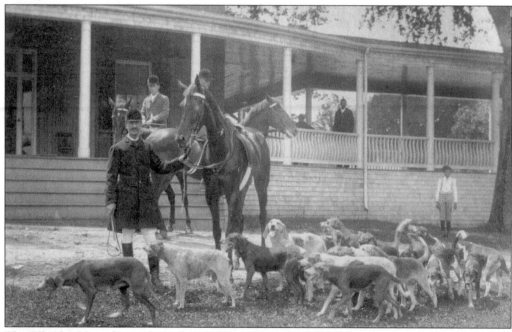

The Elkridge Hounds was formed in 1878 in Anne Arundel County. After moving to several locations, the club incorporated in 1888 and purchased the Bradford estate, known as Montevideo Park. As the Confederates had burned the governor's mansion during the war, the large tenant house was used as the clubhouse. This gentleman is ready to ride to hounds sometime in the early 1900s. (Courtesy collection of Dr. and Mrs. Charles O'Donovan III.)

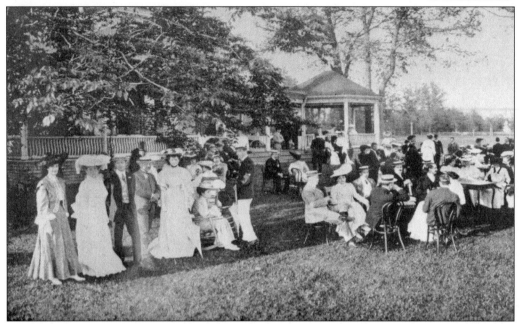

The Elkridge Club, also known as "The Kennels," connoting the club's original purpose as a hunting club, was an elegant setting for a horse show, c. 1900. Charles Street Avenue, which can be seen in the background behind the row of trees, brought with it the encroaching suburbia. Foxhunting, which requires thousands of acres of open land, became impossible at the club's location on Charles Street. (Courtesy Elkridge Club.)

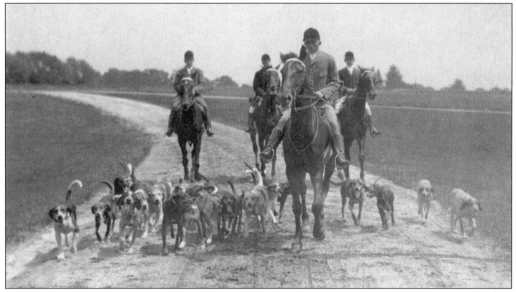

These huntsmen are following the pack down what is now the drive into the Elkridge Club. Charles Street Avenue, as it was known then, can be seen in the background. Due to the development that began to envelop the club grounds, the hunt club purchased Long Quarter Farm on Pocock Road in Harford County and moved the hunting to that location in 1920. The lovely grounds around the old club are now a first-rate golf course. (Courtesy collection of Dr. and Mrs. Charles O'Donovan III.)

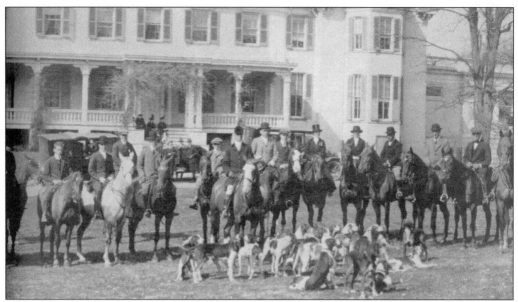

The Green Spring Valley Hunt Club gathers in front of Cliffholme, c. 1920. It was in December of 1892 that a group of hunting enthusiasts gathered to organize a hunt club in Green Spring Valley. Redmond C. Stewart, an avid foxhunter since his youth, kept the hounds for the burgeoning club at the back of Cliffholme, his parents' home. This photograph taken years later shows Mr. Stewart in the black riding hat in the center of the hounds. (Courtesy Timothy C. Naylor.)

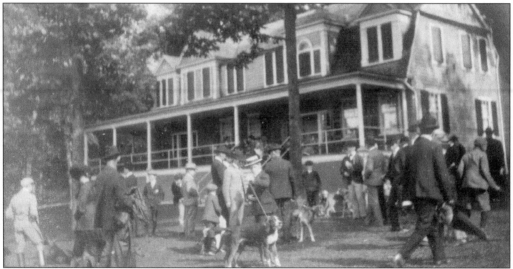

After three years of using the Ten Mile House (an inn on Reisterstown Road), the young club, with its doubled membership, purchased property from Redmond Stewart's family in 1897. Kennels, stables, and a wood shingle clubhouse, pictured above, were built on the site on Green Spring Valley Road. Soon, the club offered additional sports, such as tennis, swimming, and golf. In 1925, due to encroaching development as well as other practical reasons, the club board members decided to move the hunting aspect of the club to the Philpot House on Mantua Mill Road. As it was farther north, the Hunt Club was commonly referred to as the "Upper Club." (Courtesy Timothy C. Naylor.)

Three

FUN AND GAMES

These gentlemen are obviously enjoying their vestry meeting in May 1938. (Courtesy collection of Hildegarde Denmead LeViness.)

Dates for
1912–1913

1912
at The Lyric

Monday, December 9th
Wednesday, December 25th

1913
at Lehmann's Hall

Monday, January 6th
Monday, January 20th
Monday, February 3d

Shown here is a list of dates for the Monday Germans, which were an important part of the social lives of Baltimoreans, young and old. (Courtesy collection of Hildegarde Denmead LeViness.)

Bachelors Cotillon
Ladies Ticket

Mrs. Garner Wood Denmead

Cotillons of 1912–1913

Wm. F. Lucas Jr.
Secretary

Please present this card at the door
Cotillon dates on reverse side

Sometime in the early 1800s, a group of Baltimore bachelors decided to hold a dance as a show of gratitude for all the debutante parties to which they had been invited. Traditionally held in the first week of December, the date was changed in the mid-1900s to accommodate the fact that most young women attended college and could not come home for a dance! (Courtesy collection of Hildegarde Denmead LeViness.)

This pretty young lady is posing for a portrait to commemorate her "debut." Debutantes were young ladies, usually around 18 years of age, who would be fêted with a series of teas, parties, and dances. The season would culminate with a presentation to the Bachelor's Cotillon, which was once also known as the Monday German. Their partners, usually close friends of the debutante's father, would ensure that the young woman was properly introduced to "Society." After a pleasant supper, the group would arrive at the Lyric Opera House to find the place transformed. The orchestra seats had been removed and replaced by a dance floor. The boxes around the perimeter would be filled with hundreds of aromatic bouquets sent to the debutantes earlier that day. The girls in white, the gentlemen in white tie and tails, and the elegantly dressed matrons of Baltimore would dance well until after midnight, refreshing themselves with champagne. (Courtesy collection of Hildegarde Denmead LeViness.)

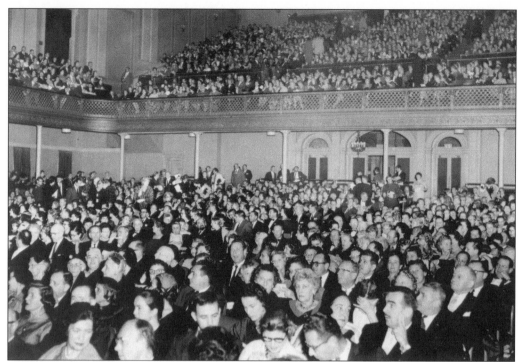

As this 1957 full house attests, Baltimoreans have long loved opera. In fact, 200 years prior, "The Beggars Opera" was performed locally in 1752. Touring productions provided entertainment until Eugene Martinet founded the Martinet School of Opera in 1924. This school later became the Baltimore Civic Opera Company, and then the Baltimore Opera Company. (Courtesy Baltimore Opera Company.)

Over the years, the Baltimore Opera Company has showcased world-renowned stars, as well as fostered local talent. In addition to regular productions, the company instituted its successful Summer Aria Series in 1993. The company also sponsors the prestigious Baltimore Opera Vocal Competition for North American Artists, as well as a program that brings opera to schoolchildren. (Courtesy Baltimore Opera Company.)

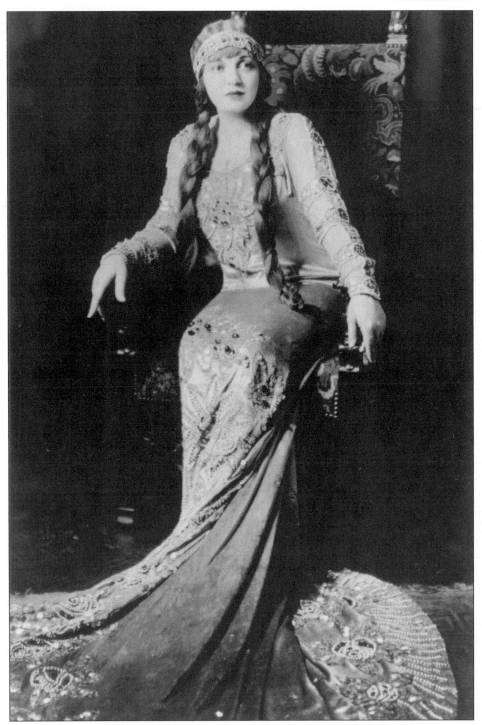

The legendary diva Rosa Ponselle poses in costume for *La Gioconda* (The Ballad Singer), by Ponichielli, in 1928. Miss Ponselle became the Baltimore Opera Company's artistic director in 1959. She played an important role in transforming it into the high-caliber, renowned organization that we know today. (Courtesy Baltimore Opera Company.)

Shown is the Mount Royal Avenue entrance into Druid Hill Park, *c.* 1910. The most prominent features of the city's skyline are still church spires and, barely visible, the Victorian tower of the Johns Hopkins Hospital. (Courtesy Enoch Pratt Free Library.)

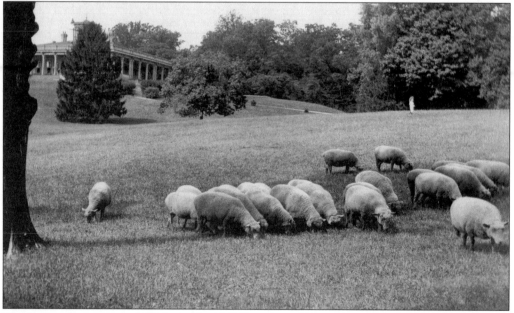

This pastoral scene on a hillside in Druid Hill park could have been captured in the early part of the century, but in fact, this photograph was taken in the early 1940s. The flock, shepherded by "Mac," was a familiar sight to park visitors. It is interesting to note that the pasture is now a part of the Baltimore Zoo. (Courtesy Enoch Pratt Free Library.)

This whimsically elaborate bandstand was another of the attractions in Druid Hill Park. One can almost hear the Sousa march that might be entertaining this audience at the turn of the twentieth century. (Courtesy Enoch Pratt Free Library.)

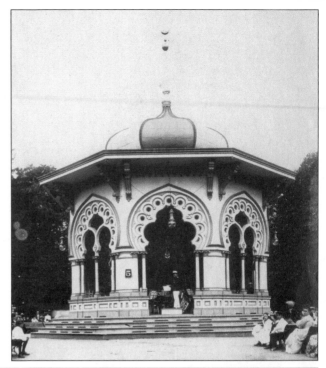

Druid Hill became a park in 1860. The miles of paths through the wooded property enjoyed by drivers, horseback riders, and walkers alike, provided the illusion of country in the middle of town. Boats could be rented by the hour on "Swan Lake," as it was known then. Of course the zoo (a fraction of its current size) was an attraction for all. Druid Hill was a welcome relief from the city heat, when, on hot summer nights, many Baltimoreans would camp out under the stars, as their homes were too uncomfortable; hard to imagine in this day and age. (Courtesy Enoch Pratt Free Library.)

This gymnasium at Evergreen is a far cry from the sleek, highly technical home gyms of today, but it does illustrate the quest for a "sound body and mind" that was so prevalent in the leisure class at the turn of the twentieth century. Alice Warder Garrett would eventually convert this space into her theater, thereby trading one pursuit for another. (Courtesy collection of the Evergreen House.)

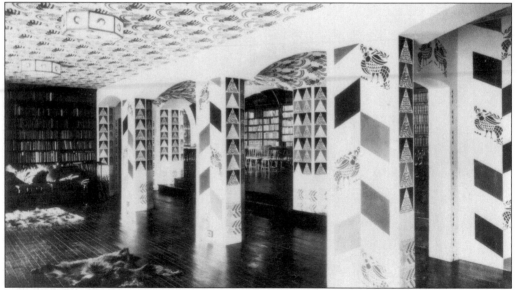

Alice Warder Garrett's keen interest in the performing arts is reflected in one of the more remarkable features of Evergreen. Shortly after the John W. Garretts took up residence at Evergreen, his childhood gymnasium was converted to a theater. Leon Bakst, set and costume designer for the Ballet Russes, created the vibrant stencils that decorate virtually every surface but the floor. (Regrettably, a black and white photograph cannot do them justice.) The Garretts provided enjoyment for Baltimore's music aficionados by hosting the Musical Art Quartet each spring and fall. (Courtesy collection of the Evergreen House.)

Alice Warder Garrett would occasionally entertain guests with her own performances. On at least one occasion, a guest was inspired to join in. In Christopher Weeks' biography of Harvey Ladew, Mr. Ladew describes a wild evening: Alice Garrett and the well-known interior designer and Baltimore native Billy Baldwin were dancing the flamenco so enthusiastically that Mrs. Garrett tripped and fell on Baldwin's leg, resulting in a fracture and a trip to Johns Hopkins Hospital! (Courtesy collection of the Evergreen House.)

Amateur theater groups have often been a popular pastime for Baltimore's "Smart Set." This photo, taken in the mid-1940s shows some of the glamorous members of the cast of the "Paint and Powder Club" in their more accustomed attire. Founded in 1894 as an outlet for creative energy, all parts were played by men. Women later proved a welcome addition to the cast. (Courtesy collection of Hildegarde Denmead LeViness.)

This could be a scene from *My Fair Lady* as the elegant behatted crowd members display various levels of interest in an equestrian competition. (Courtesy Elkridge Club.)

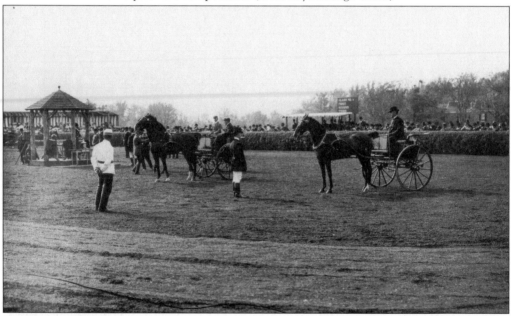

Several horse shows were held throughout the season. Perhaps the show that drew the most attention, both locally and nationally, was the Worthington Horse Show. Wilbur Miller (of Pleasant Hill) built the showgrounds near the corner of Tufton Avenue and Dover Road. The show was widely regarded by horse lovers to be the highlight of summer. A large grandstand, covered by a striped awning, accommodated spectators, many of whom came from out of the state. (Courtesy Enoch Pratt Free Library.)

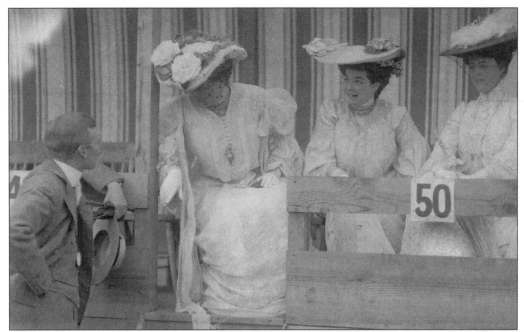

These beautifully turned out ladies, complete with hats, veils, gloves, and parasols, are enjoying an afternoon of conversation at a horse show. The box they are seated in is a far cry from the luxurious skyboxes found at some of today's sporting events. Then again, they are far better dressed than the average sports fan! Chatting with Mr. Eugene Levering are, from left to right, Mrs. W.S.F. Williams (Bell DeFord), Mrs. Sherlock Swann (Edith DeFord), and Mrs. Joseph Widener. (Courtesy Elkridge Club.)

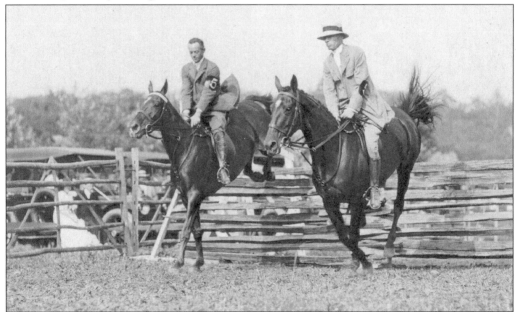

Pictured here is an entry in the "Pairs of Hunters" class. A good hunter had to be fast, but more important was its jumping ability and endurance. Many a horse has made it to the home stretch only to fall at the last fence. (Courtesy Timothy C. Naylor.)

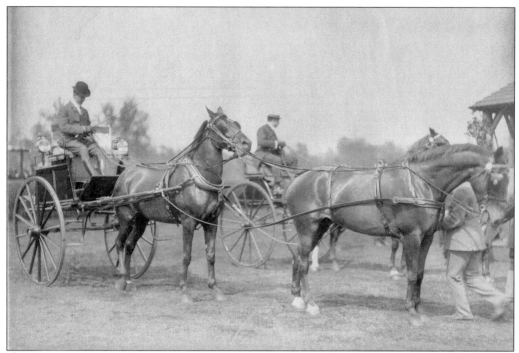

Driving competitions were a popular entertainment. Horses were judged on manners, quality, and performance, including the ability to stand quietly, back easily, and possess a perfect mouth. It was important to have a smart lead horse when driving. (Courtesy Elkridge Club.)

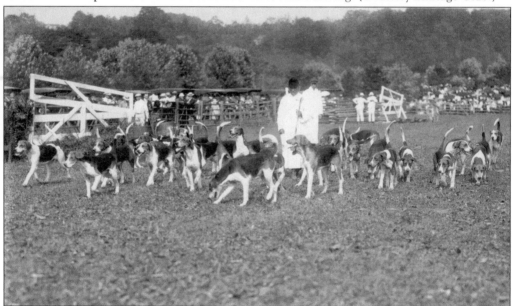

Valued for their endurance, scenting ability, and "clear voices," the hounds were bred with an almost scientific approach by the master of fox hounds, or MFH. These hounds, never called dogs, are demonstrating their quality and excellent training at a horse show in the Worthington Valley. Dog owners can marvel at how controlled this large pack seems to be! (Courtesy Timothy C. Naylor.)

For generations, Baltimore hunters have traveled to the hunting lodges and camps that dot Maryland's famed Eastern Shore. The ribald stories and silent companionship that were shared in blinds like this one in Charlestown, Cecil County, lend the sport a dimension seldom recognized by the uninitiated. (Courtesy Enoch Pratt Free Library.)

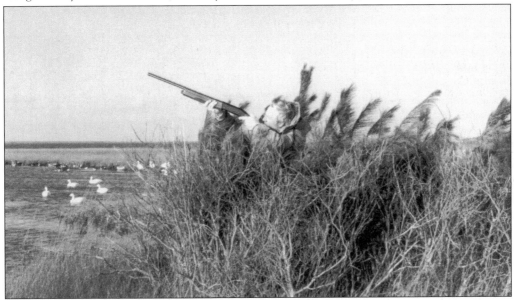

A hunter takes aim on Maryland's Eastern Shore. Long regarded as one of the best hunting grounds in the world, the Eastern Shore was within a half-day's drive for Baltimore hunting enthusiasts. Before the Bay Bridge was built, hunters could either take a steamer across or drive north and around the bay. Elegant inns, such as the Tidewater Inn in Easton, would provide Baltimore hunters with a comfortable place to stay after a cold day in a hunting blind. Some businessmen would form syndicates and buy property on the shore, creating hunting "camps." (Courtesy Mr. and Mrs. Hal C. Whitaker.)

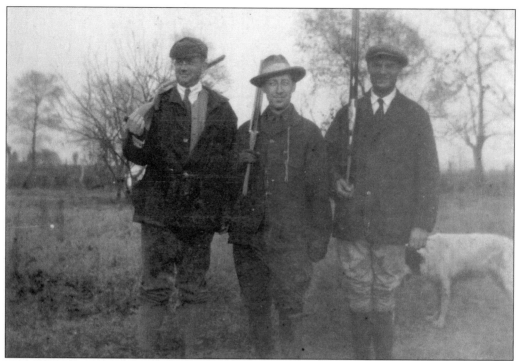

Pictured here are Garner Denmead and fellow sportsmen, along with four-footed friends. Hunting and shooting, for both sport and sustenance, have always been popular activities. (Courtesy collection of Hildegarde Denmead LeViness.)

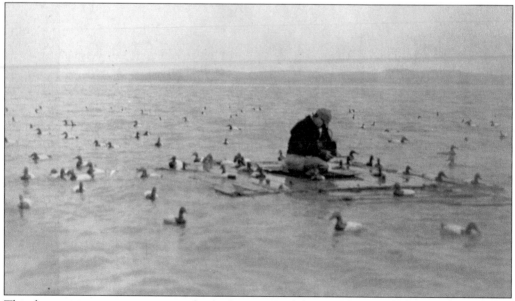

This hunter is setting out canvasback decoys. Widely regarded as the best tasting duck, canvasbacks were almost hunted to extinction. One of the reasons for this was the use of a "sink box" (pictured above): a blind that was almost completely submerged under water. This allowed hunters to conceal themselves in a flock of decoys. It is due to its effectiveness that the sink box was finally banned, as was hunting canvasbacks. (Courtesy Enoch Pratt Free Library.)

One of the aspects of hunting that made it so enjoyable was the partnership between a hunter and his dog. Stories of heroic dogs abound, as do the more amusing stories of young dogs that still had a lot to learn. Whether it was upland game or waterfowl, a hunter relied on the keen senses and tireless enthusiasm of a well-trained dog. No matter how good a shot he might be, if the quarry wasn't retrieved, there wouldn't be any roast goose for supper! (Courtesy Mr. and Mrs. Hal C. Whitaker.)

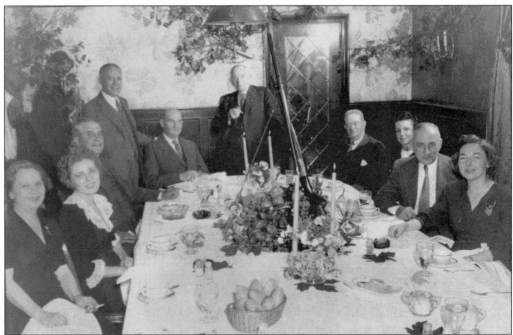

The unusual centerpiece, which includes a fishing rod and a shotgun, as well as the autumn leaves and branches scattered around the walls and on the table, show the shared interests of this party of sportsmen (and women). We assume they provided the bulk of the menu. (Courtesy collection of Hildegarde Denmead LeViness.)

These four Baltimore "swells" are enjoying an afternoon on the Severn River, *c.* 1925. From left to right are Charles Evans, Hugh Smallwood, Rignal Baldwin, and Jack Croker. (Courtesy Mr. and Mrs. Hal C. Whitaker.)

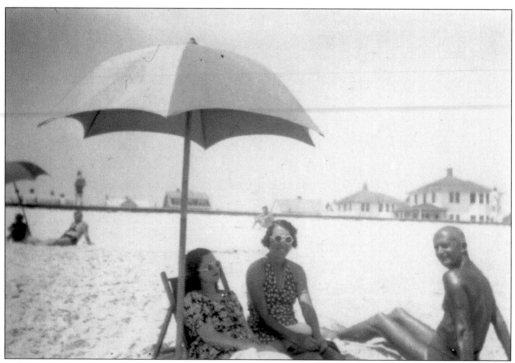

Baltimoreans have always loved outdoor activities, including all manner of seaside sport—sailing, fishing, swimming, and sunbathing. For generations, families have decamped for all or part of the summer. Rehoboth, seen in this *c.* 1940s photo, has always been a popular destination due to its accessibility. (Courtesy collection of Hildegarde Denmead LeViness.)

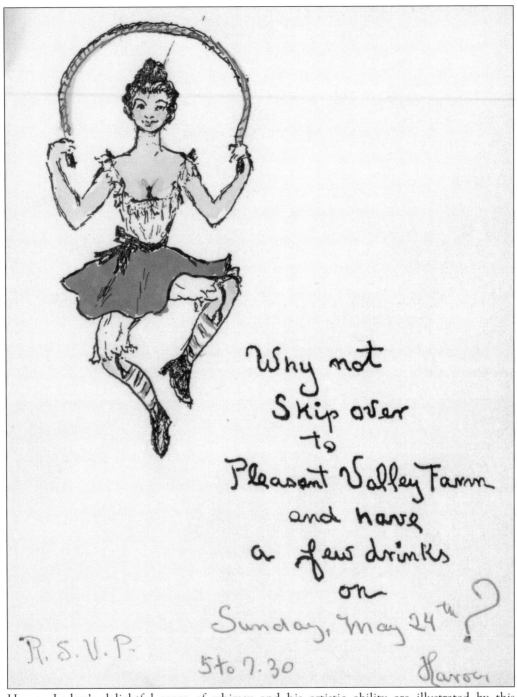

Why not
Skip over
to
Pleasant Valley Farm
and have
a few drinks
on
Sunday, May 24ᵗʰ?

R.S.V.P.

5 to 7.30

Harvey

Harvey Ladew's delightful sense of whimsy and his artistic ability are illustrated by this charming invitation to Pleasant Valley. Frequent guests of Mr. Ladew, who entertained well and often, included both local and foreign friends, as Mr. Ladew's company was almost universally enjoyed. Mr. Ladew conducted a regular correspondence with the Duchess of Windsor and provided frequent grist for Billy Bachelor's society column in the *Baltimore Sun*. (Courtesy Ladew Topiary Gardens.)

We hope this little girl won this class, as it is twice as hard to ride sidesaddle (as she is), not to mention while wearing a white dress! (Courtesy Elkridge Club.)

Two turn-of-the-century (as in twentieth century) ladies strike an affectionate pose for the camera. Amateur photography was still in its infancy at this time and an expensive hobby. (Courtesy collection of Hildegarde Denmead LeViness.)

Posing for a formal portrait, this cooperative child is bundled from head to toe in white rabbit fur. She looks as if she is well prepared for the worst a Maryland winter has to offer. (Courtesy collection of Mr. and Mrs. Allan Mead.)

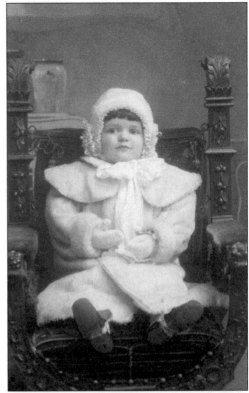

Mr. and Mrs. Robert Walker return from a sleigh ride on a snowy afternoon. Though not a typical winter activity today, this photograph reminds us of the not too distant past when country folks were obliged to take a sleigh to church or to visit neighbors when it snowed. (Courtesy Enoch Pratt Free Library.)

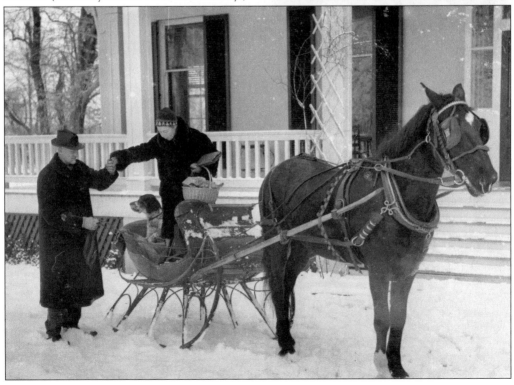

In contrast to Evergreen's ornamental style, Alice Whitridge Garrett's rustic "Tea House" was tucked in the back of the garden. Complete with a thatched roof and leaded-glass windows, this little playhouse for grown-ups must have been a whimsical place where she could retreat from the responsibilities of running a large household without benefit of a husband by her side. (Courtesy collection of the Evergreen House.)

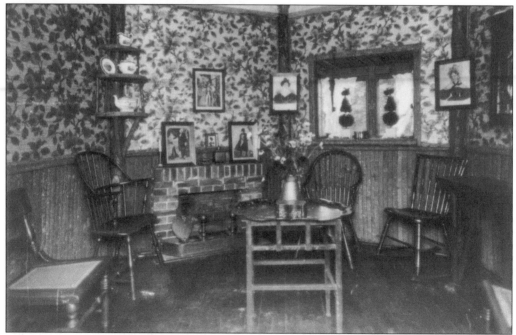

The interior of the Tea House boasted a fireplace for chilly afternoons, rustic furnishings, wallpaper, and topiary in the window. One has to wonder what inspired Mrs. Garrett to include portraits of George Washington and Napoleon on the mantle of this little sanctuary! (Courtesy collection of the Evergreen House.)

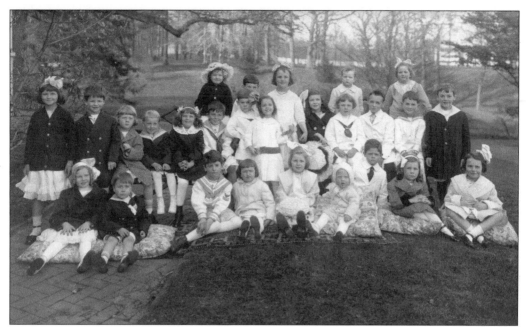

A happy (for the most part!) group of children gather for a birthday party. Note the drop-waist dresses and sailor's outfits that were so popular at the turn of the twentieth century. This picture was taken at Mondawmin, the home of George S. Brown. One day, these little children would return to this spot as adults to renew their driver's licenses! (Courtesy collection of Dr. and Mrs. Charles O'Donovan III.)

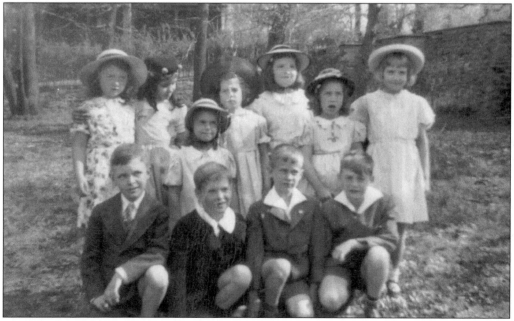

This charming photograph shows a 1940s Sunday school class at St. David's Church on Roland Avenue. Founded in 1906 and named after the patron saint of Wales, the church has been a mainstay of community life for many years. (Courtesy collection of Hildegarde Denmead LeViness.)

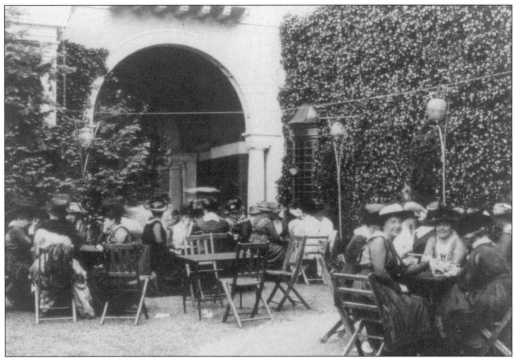

While her son John was posted in Paris, Alice Whitridge Garrett gave a card party to benefit the war effort, *c.* 1918. Gathered under and around the porte-cochere, ladies enjoy tea and cards while doing their patriotic duty. (Courtesy collection of the Evergreen House.)

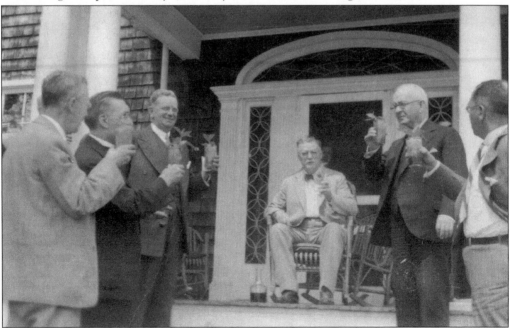

Marylanders are rightly celebrated for their hospitality, good food and drink. Perhaps these gentlemen are sharing a pre-prandial toast before lunching on some local delicacies. (Courtesy collection of Hildegarde Denmead LeViness.)

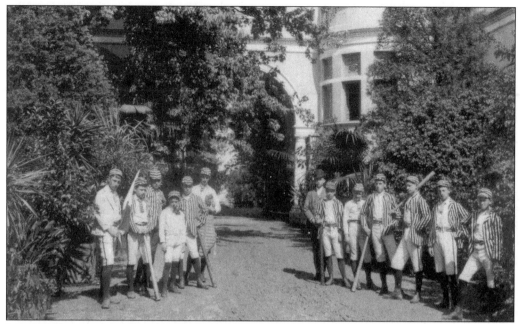

John W. Garrett's childhood at Evergreen was idyllic by any standards. He and his two brothers, Horatio and Robert, were provided with tutors and a gymnasium. Additionally, the boys were members of an early "Little League." In this photograph, *c.* 1885, the team poses in front of the porte-cochere before a game. (Courtesy collection of the Evergreen House.)

Even in 1901, springtime marked the beginning of baseball season. Here, some fans take a break from the action at a game on the grounds of Homewood. (Courtesy Homewood House Museum, The Johns Hopkins University.)

Maryland is ideally suited for horses, so it naturally follows that "The Sport of Kings" would be one of the most enduring sports in Baltimore. After the Civil War, Governor Oden Bowie (inspired at Saratoga) helped to revive the Maryland Jockey Club. Pimlico, an estate northwest of Baltimore City, was purchased for the purpose of building a racetrack. The first races at Pimlico were run on an autumn afternoon in 1870. The winner of the featured race was a bay colt named Preakness. The second leg of the Triple Crown and the race that made Pimlico famous, was first run in May 1873. The race pictured here was run during the 1930 season. (Courtesy Enoch Pratt Free Library.)

Mary Mead (center) and two friends enjoy a day at the races. (Courtesy collection of Mr. and Mrs. Allan Mead.)

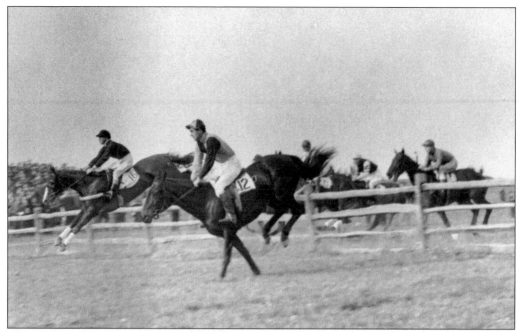

These horses have just cleared the timbers and will race to finish the Maryland Hunt Cup. Regarded as one of the toughest timber races in steeplechase, the Hunt Cup is the third race in a series of three; the first two are The Manor Race and the Grand National (Maryland's version). It results from a gentleman's challenge in 1894 between the Elkridge Fox Hunting Club and the Green Spring Valley Hunt. The 4-mile course that was run on May 26, 1894 finished at Brooklandwood (the estate was owned by George Brown at the time). John McHenry won the race on Johnny Miller. (Courtesy Enoch Pratt Free Library.)

A huge crowd enjoys the Maryland Hunt Cup, c. 1947. The spectators are lined along the home stretch, ready to cheer their horse home. For the first several years, the Hunt Cup was only a local event, but when its reputation as the most challenging steeplechase in the United States (some say in the world) began to spread, the crowds became much larger, and entries into the race began to come from other parts of the country. (Courtesy Mr. and Mrs. Hal C. Whitaker)

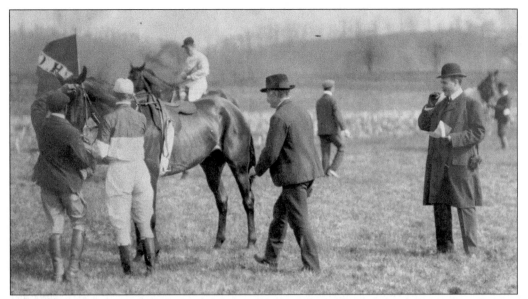

Redmond C. Stewart prepares to mount Landslide at the 1904 Maryland Hunt Cup. Stewart recalled Landslide as being the greatest horse he ever rode. Mr. Stewart and Landslide went on to win the race. Note the Hunt Cup flag on the left of the image with its diagonal white stripe and the initials, H.C.. (Courtesy Timothy C. Naylor.)

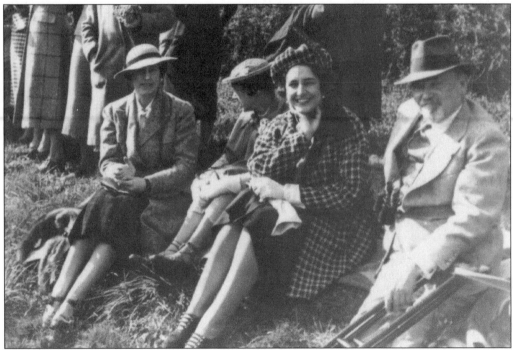

Mr. and Mrs. John W. Garrett enjoy the Maryland Hunt Cup with friends, c. 1930. It has long been the tradition to bring a luncheon to the Hunt Cup. Everything from fried chicken and sandwiches to tenderloin and crabcakes are served on china and silver. Champagne icing down on the open back of an old wood-sided station wagon evokes many memories of the Hunt Cups of old. (Courtesy collection of the Evergreen House.)

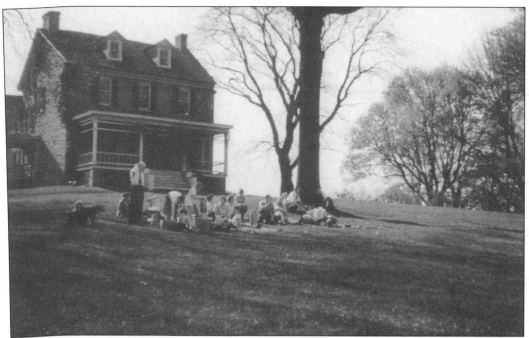

Pictured is a picnic on the front lawn of Duddington, c. 1950. This picnic was held every year on the day after the Hunt Cup for friends of Mr. and Mrs. J. Martin McDonough. (Courtesy Mr. and Mrs. Hal C. Whitaker.)

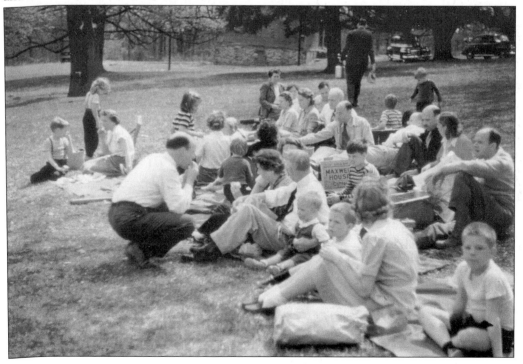

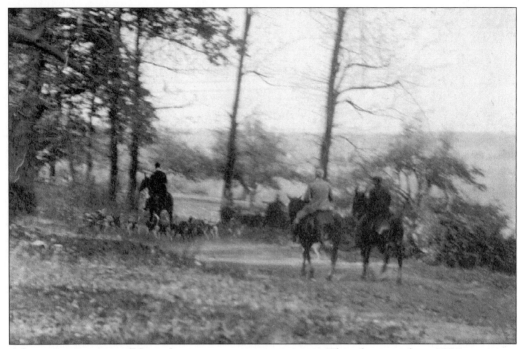

A hunting party sets off for a chase on an autumn morning. This photograph, c. 1920s, captures a time when the countryside was a little wilder, the roads and houses fewer. The hunts would traverse many miles across pasture and farmland. Only through history or the recollections of others can we recall the lifestyles cultivated by the first gentlemen and gentlewomen of the area. For better or for worse, Baltimore and the countryside around it have changed a great deal since then, though there are still pockets of tradition where their memory is invoked. Tally Ho! (Courtesy Timothy C. Naylor.)